NATIONAL GEOGRAPHIC
CAT
SHOTS

[*Following pages*]

James L. Stanfield
JAPAN ~ 1994

In Tokyo's sprawling Tsukiji fish market, it only took a blink of the eye—and
shutter—before this cat and her brood disappeared behind the gaping crack
that was their doorway to shelter.

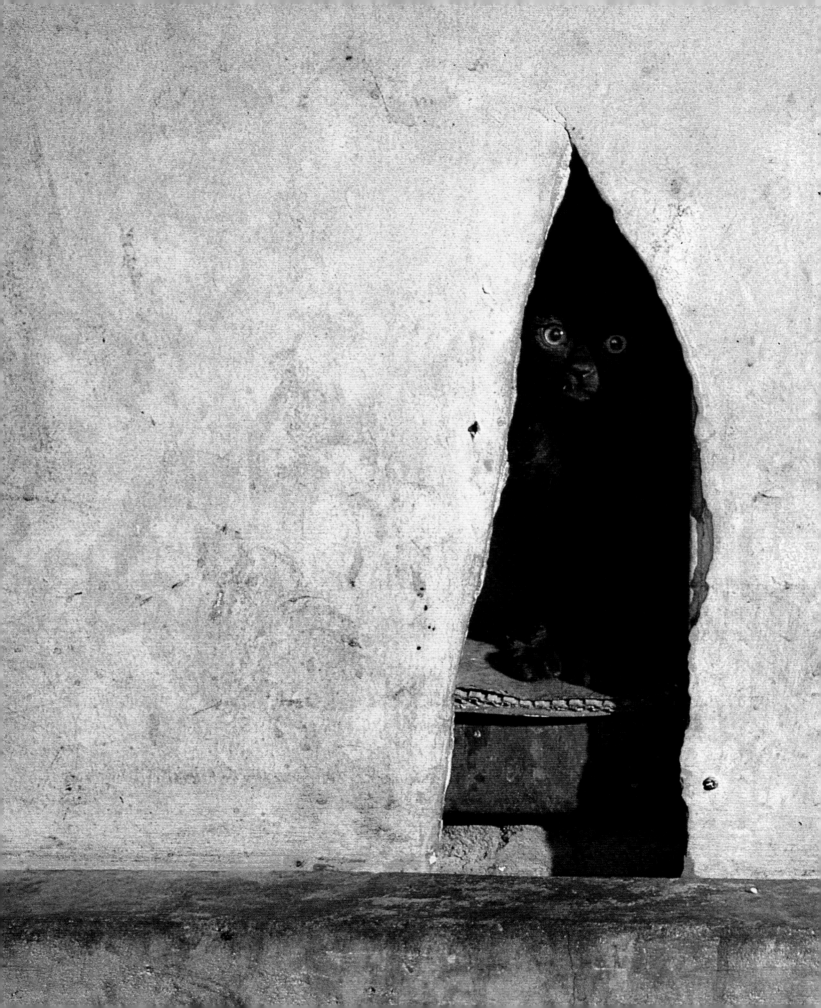

NATIONAL GEOGRAPHIC
CAT
SHOTS

Text by Michele Slung

**NATIONAL
GEOGRAPHIC
SOCIETY**

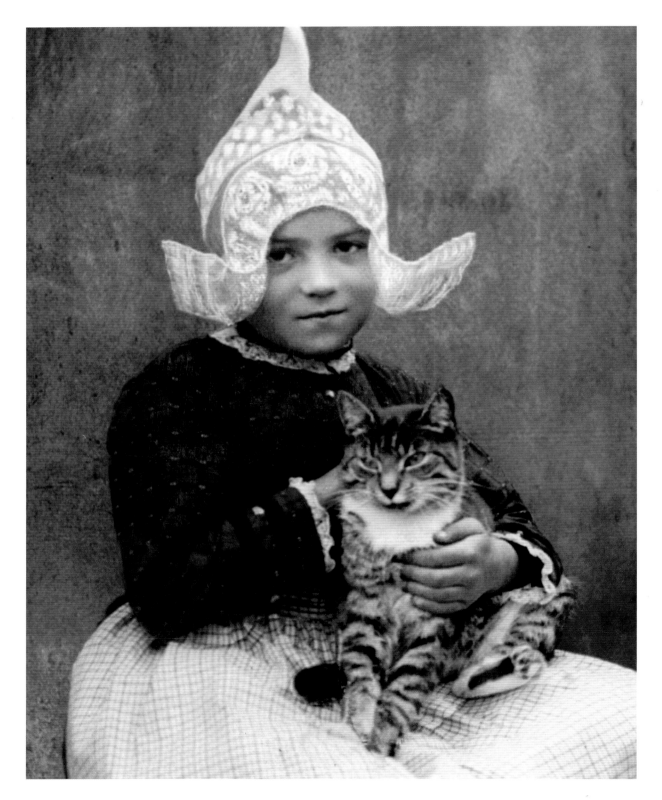

Donald McLeish

HOLLAND ~ 1920s

A young Dutch girl in traditional costume gently holds a striped cat.

THE ACCIDENTAL CAT PHOTOGRAPH

Cats are private creatures who live in public places.

Often, though, they are merely passing through—pausing only long enough to magnetize our glance.

At other times, we simply sense their presence, prickled at the back of our consciousness by the residue of their mysterious grace. But always the very fact of them changes whatever surroundings they enter, and not just the visual substance of what's on view, but its emotional content as well.

Contemplating the images in this book—all but a very few of which were taken while on assignment for NATIONAL GEOGRAPHIC—one comes to recognize that the photographers who shot these memorable pictures also slip into a landscape and then transform it.

A famous proverb tells us, "A cat may look on a king." Yet here we are able to enjoy those striking moments when the opposite has been the case. The king, so to speak, has looked back.

Thus, do cat magic and camera magic converge.

Living daily with a cat—or cats, since the enjoyment of their company can be addictive—has been known to make dedicated cat watchers out of the least likely people. For to observe the most ordinary cat activity is to experience sheer wonderment at the careless yet composed nature, the transcendent *specialness*, of feline beauty.

And yet, as we know, many a doting cat owner, camera in hand, may wind up with nothing more than a pretty picture— the usual lovable bundle of whiskers and fur—to show for his or her efforts.

In *The Velvet Paw: A History of Cats in Life, Art and Mythology*, Jean Conger writes, "Cats tease photographers because they are very photogenic." That is, the innately contrarian nature of cats—the flip side of which, as all cat owners usefully learn, is their pets' susceptibility to reverse psychology—forever guarantees their unsuitability as reliable models.

In other words, cats never pose, they just *are*.

Lewis Carroll showed how well he understood this when he created that icon of literary perversity, the Cheshire Cat. "'All right,' said the Cat; and this time it vanished quite slowly, beginning with the end of the tail, and ending with the grin, which remained some time after the rest of it had gone."

However, in what one might call traditional NATIONAL GEOGRAPHIC terms, the presence of a cat, grin and all, in any photo layout actually is pure frosting. Only on the rarest of occasions has a photographer working for the Society headed out on assignment specifically searching for *Felis catus,* or the common house cat. (Their much larger wild cousins—lions, tigers, panthers, and all the other majestic feline beasts—are a different story.)

None of them have ever come back, either, boasting of how successfully they stalked the elusive wild kitten.

Nevertheless, from every corner of the earth, hundreds of cats and kittens have crept into the National Geographic Society's photographic files (sneakily, some might even say, and thus true to their nature). And there they've settled and remained since the earliest days of the Society's mission, anonymously spanning the world's cultures across decades of film.

Not all of these images, in fact, were produced by photographers working in an official capacity, since, in the early days, numerous photographic collections were offered to the Society and purchased in order to increase the collection's breadth. These aged oddments, which can include anything from comic setups to photos off the newswires to studio portraits, now add wonderfully eccentric notes to the treasures at hand.

While a number of these images have appeared in the pages of National Geographic publications, and a few have even been widely reproduced, most are on view here for the first time.

Until now these pictures have been primarily the private delight of Society archivists, illustrations editors and researchers. For the hard-core cat fanciers among this group, having access to such a resource has been the equivalent of a secret stash. And with thousands of rolls of film always being shot, there was everyday the possibility of some unexpected and enchanting cat to be glimpsed.

These shots, recording the reality of faraway places, lend to the exotic, as well as to the merely distant, an engaging note of the familiar. And though we have heard all too often that a single picture is worth more than a thousand words, many of these images carry with them stories that until now have never been told.

Whether it's the apparently unfazed black kitten, captured both

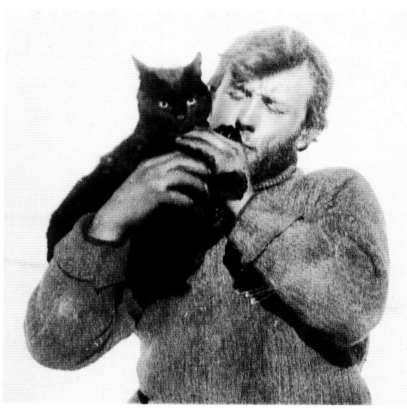

Adm. Robert E. Peary Collection

Michael D. Wallace
ANTARCTICA ~ 1912

This cat, held by a crew member
aboard Capt. Robert Falcon Scott's
ship, *Terra Nova*, en route to
Antarctica in 1910, was in fact part
of what one contemporary observer
described as "a floating farmyard."
As it set out, the expedition also
housed 19 ponies, 33 sled dogs, and
several pet rabbits on the boat's
upper deck. Scott, eager to reach
the South Pole first, did not suc-
ceed, losing to the Norwegian
explorer Roald Amundsen.

Adm. Robert E. Peary
CANADA ~ 1900

Marie Ahnighito Peary, nicknamed
the "Snowbaby" by the Eskimos
among whom she grew up, was a true
child of the north. Born in 1893 in
Greenland, she was 7 when this
photograph was taken by her father,
Adm. Robert E. Peary, aboard the
S. S. *Windward*. "My kitty is very
wild," she wrote in a letter, "and will
not come to me, though I feed her
milk and bread and try my best to
make friends with her."

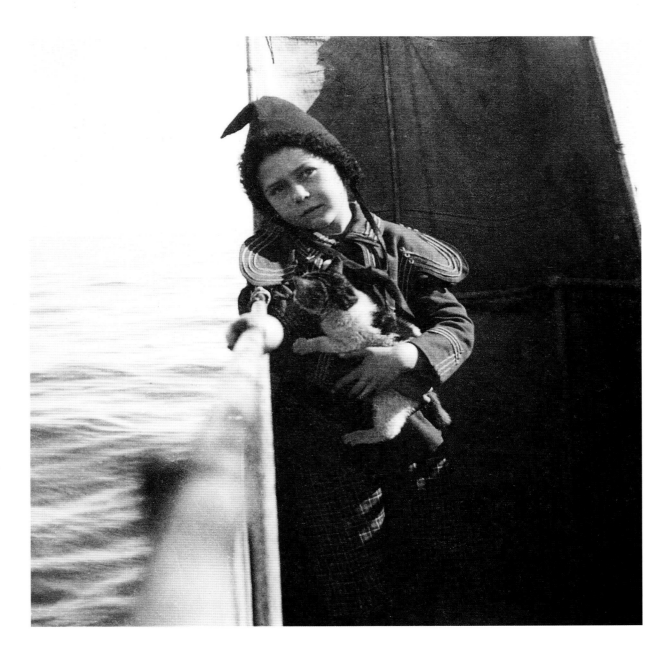

by a Texas cowboy's lasso and Joel Sartore's camera, or the pair of lissome adolescents spotted by Jim Stanfield begging for breakfast on a mountaintop in Greece, the cats we see in this book are in the midst of inhabiting their own worlds. That means, equally, the universal cat place, where all cats dwell, as well as the location of the photographer's assignment.

The idea of different worlds here also signifies earlier eras not our own. And if the well-groomed cat has changed little since its ancestors were worshiped as gods in Pharaonical Egypt, its human companions have at times altered not just themselves but the world around them.

Beginning in about 1500 B.C., images of common pet cats started to appear in the scenes Egyptians painted on the interior walls of tombs. Hardly different from their whiskered descendants we alternately stroke and chide today, these representations amaze with their extraordinary ordinariness: Nothing is the same, and everything is the same. We know this already, and yet when *cats* tell us, we believe it just that much more.

And as cats continued to infiltrate ancient households, first smuggled as contraband up into Greece and then slinking across the whole of Europe, they served as unawed, if undoubtedly purring, witnesses to all of modern history.

Man, in addition to altering his near surroundings continually to suit his needs and desires, has also kept on broadening his territory. The beyond has always beckoned. However, until the advent of photography, records of distant discoveries and impressions were kept with maps and drawings, correspondence and journals.

Photography, though, was to make rapid inroads into this time-honored process of painstaking description. Invented in the 1820s,

by the turn of this century, it was soon the medium for bringing back proof of daring exploits on every continent.

As we see, cats are very much included.

What's amazing, then, is how the cat, by its existence, manages to unify such a diversity of recorded moments. Time and space are bridged in an instant—and so easily!—as cats bear unselfconscious witness to that continuum of pleasure expressed when their lovely supple weight is clutched close. The relaxed intensity on the face of each person holding a cat somehow always looks the same.

The cats, in turn, nestle against their temporary protectors in identically snug fashion. Whether en route to the South Pole in 1910 or on the streets of South Florida some 80 years later, in the 1920s Netherlands or upstate New York of the 1990s, they remain predictably focused not on the camera but on the more pressing matter of their own security and comfort.

Most tellingly, the kitten All Ball, cuddled by the gorilla Koko (right), in 1984, is likely experiencing the same warmth as would any other of his species so tenderly gripped. The great ape, in turn, looks just as blissful clasping the kitten to her vast chest as do any of her own relations further along the evolutionary ladder.

There is room to speculate how much of the cat's appeal lies in its unmatchable softness, in the way that its texture and its form merge into one perfect whole, simultaneously yielding and yet distinct. "A cat pours his body on the floor like water," noted American writer, William Lyon Phelps. But, actually, the cat's unique trick is always to retain its own identity even at its most fluid.

Cats also make contrasts, and contrasts *make* photographs. In the most obvious sense—as in black or white, tiger or tabby—cats are design elements, absorbing or reflecting light, and adding a patterned flourish. But in other ways, the contrasts provided by cats are more subtle: The image of a smoke-colored kitten gazing up (and up and up) a ballerina's pale ivory legs is one that touches our mind along with our eyes.

Meanwhile, the sight of a cat gently being cradled by a tattooed young cowpoke—or a grizzled French pensioner or an Indian nomad toddler or an Ethiopian beauty or a streetwise Miami teenager—succeeds in reaching straight into our hearts, as well.

Sleeping more than half the day, as they do on average, cats embody the very essence of relaxation—and we admire and envy them for it. Television commentator Jane Pauley is credited with the observation "you can't look at a sleeping cat and feel tense," while the poet Baudelaire spoke of how they seem to be "dreaming dreams that have no end."

Thus, though their every movement is a kind of miracle, cats, even when inactive, command our attention. For example, Susie Post's picture of an Irish family's calico drowsing beneath a heavy, hot stove is a visual ode to domestic peace and comfort.

Yet, in a photo like the one taken by David Doubilet in Australia, of a watchful black cat and a valuable pile of loose cultivated pearls, there is even a sort of kinetic excitement in the very stillness of the animal. It's what the cat's capable of and still *not* doing that makes an image such as this one so completely unforgettable.

About their various far-flung encounters with cats, the photographers reflect a range of attitudes that vary from abiding affection to pure pragmatism. Admits Maggie Steber, "I'm a sucker for cats. If there's one around I'll try to photograph it over

anything else." And here's Melissa Farlow—"I'm always aware of them when I'm working. They're so wonderfully unpredictable." Says Bill Allard, "I'm just like the cat—always hunting."

And because of their vaunted curiosity, cats routinely create what Guillermo Aldana terms a "feeling of 'aha!'" or what Bruce Dale describes as a "doubletake moment." It's an instant that "just happens," Dale explains, an opportunity to be seized and never questioned, and each of his peers understands exactly what he means.

To take one example, on pages 58-59, we see what would have been a handsome if banal shot of a crumbling yellow wall in a Portuguese village turned into a hauntingly elegant study, simply by the presence of a long-legged black cat. His camera at the ready, Bernard Wolf, like his peers, was able to react in that necessary second, responding with the calm urgency that is the essence of the peripatetic photographer's art.

Traveling the world, professional photographers, by temperament and by necessity, are independent sorts. This self-reliance, of course, is a characteristic they share with cats. They are also equally curious and just as single-minded in pursuit of their prey. Photographers, naturally, sleep quite a bit less than cats, but then cats, unlike these prowling humans, prefer their own backyards to distant continents.

In *The Cat That Walked by Himself,* Rudyard Kipling lyrically pinpointed the difference between cats and other domestic animals. "But when he has done that, and between times, and when the moon gets up and night comes, he is the Cat that walks by himself, and all places are alike to him. Then he goes out to the Wet Wild Woods or up the Wet Wild Trees or on the Wet Wild Roofs, waving his wild tail and walking by his wild lone."

In these pages, cat and photographer have walked together. ■

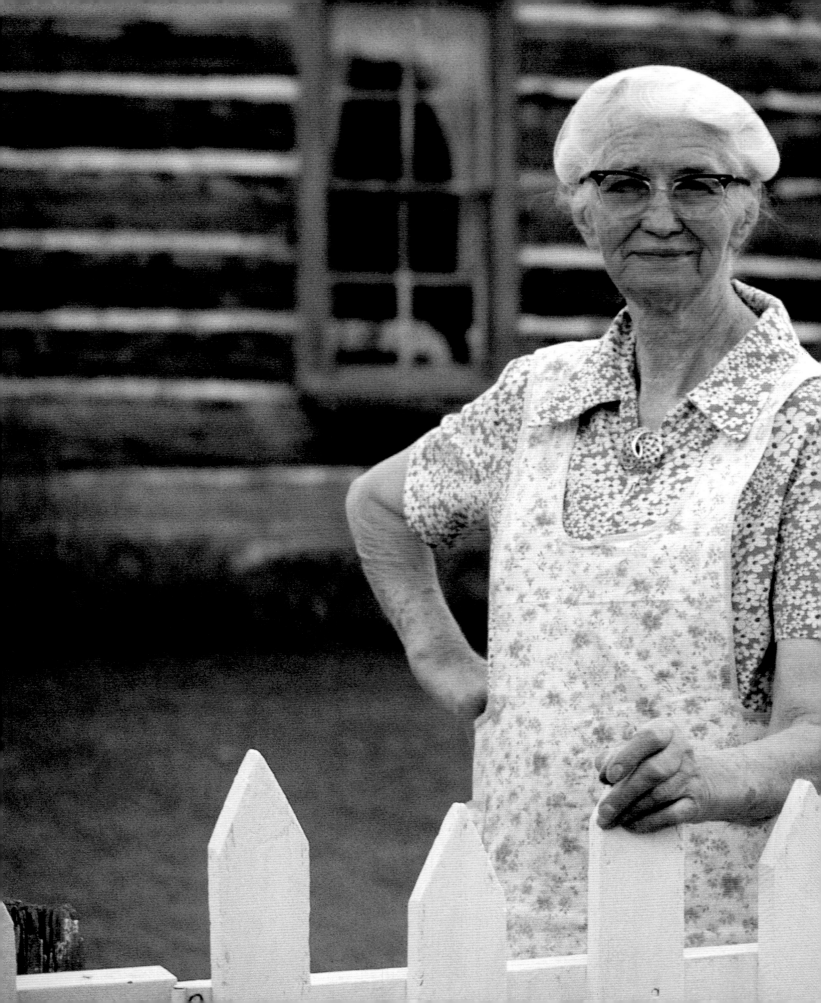

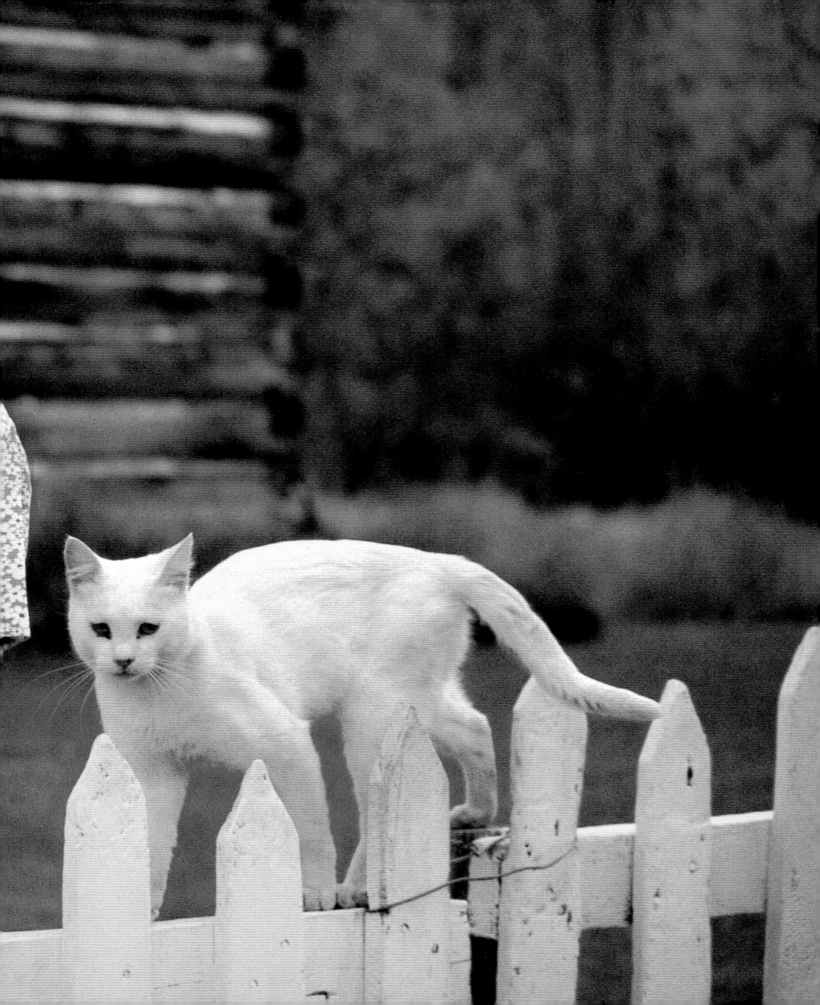

Bruce Dale
COLORADO ~ 1972

[*Preceding pages*] Jennie Schmid was 80 years old when this photograph was taken by Bruce Dale. Her family had long been ranchers in the mountains near Wilson Mesa in southwestern Colorado. The subtle resemblance that can exist between pet and owner is beautifully illustrated in this dual portrait.

Bruce Dale
HUNGARY ~ 1969

This child, with his smudged face, tousled hair and slightly impatient young cat, was photographed by Bruce Dale while visiting a Hungarian gypsy camp as part of a book assignment. *Gypsies: Wanderers of the World* was published in 1970, but the urchin, like his legendary tribe, could belong to any era.

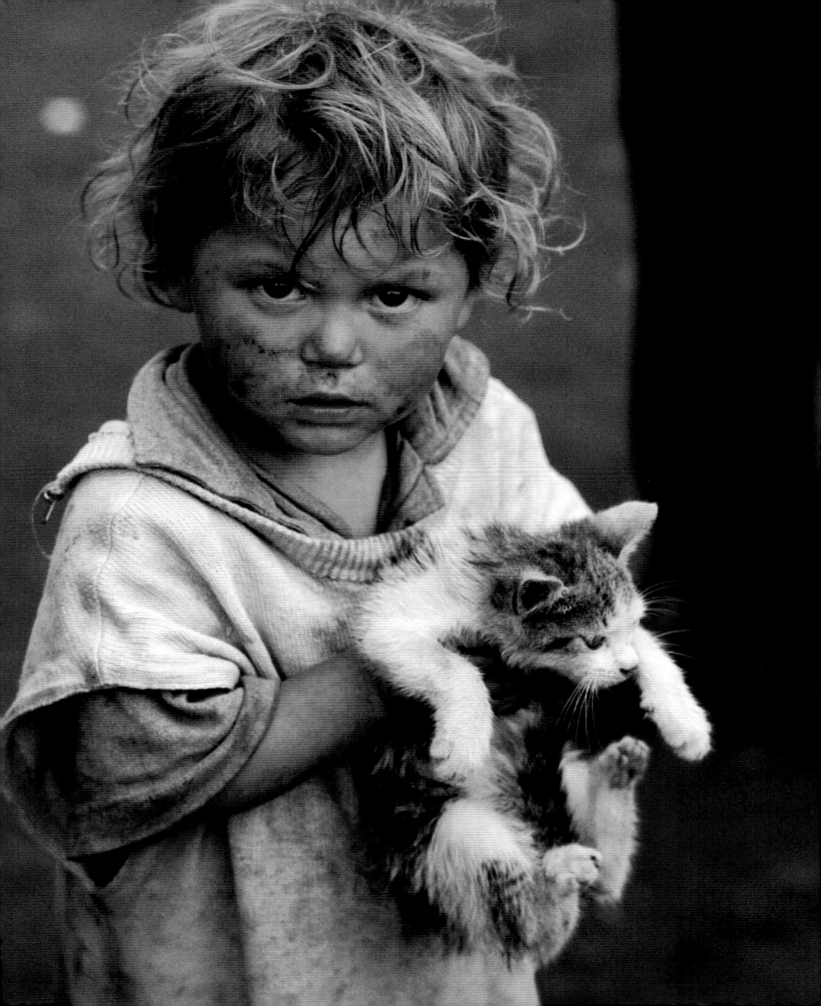

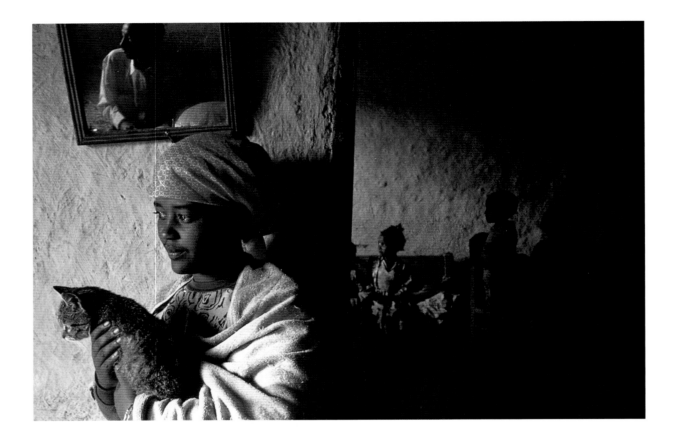

Chris Johns
ETHIOPIA ~ 1988

In a small cafe in Ankober, Ethiopia,
Chris Johns, on assignment in East
Africa's Great Rift Valley, watched
this red-kerchiefed young woman
and her cat. "In Africa, you see a lot
of harshness. This was near a war
zone, too, in a remote part of the
Ethiopian highlands, which made it
seem even harsher. So the genuine
tenderness I sensed here stood out
in contrast." Cats can add "an ener-
gy and a serendipity to a picture," he
adds. "A cat softens, and it lends to
humans a softness."

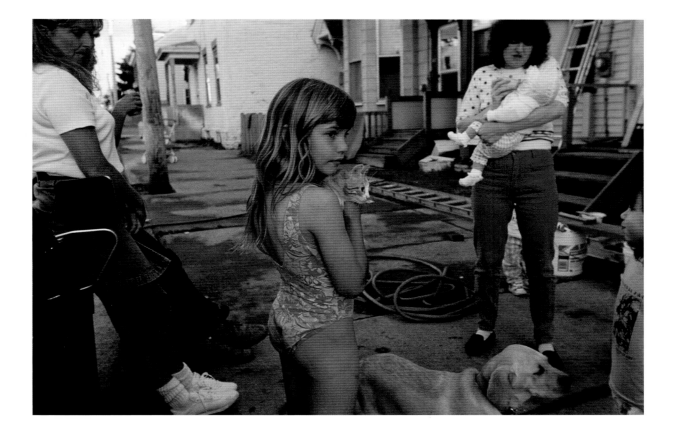

Melissa Farlow
NEW YORK ~ 1994

"I was working on a story about the
Hudson Valley, and I wanted to see
what a neighborhood in one of the
river towns felt like at street level.
It was a pretty warm day, and I was
cruising in my car through Hudson,
New York, just looking around."
That's how Melissa Farlow remem-
bers it. To her, it seemed as if
the little girl she photographed was,
somehow, "expressing herself
through her cat."

James L. Stanfield
ARKANSAS ~ 1974

"A home without a cat, and a well-
fed, well-petted and properly
revered cat, may be a perfect house,
perhaps, but how can it prove its
title?" Or so wondered Mark Twain.
Photographer Jim Stanfield was
traveling the banks of the Missis-
sippi, following in Twain's own
footsteps, when he happened across
Mrs. Addie Jackson. A survivor of
the record 1927 flood, she, along
with her cat companions, had stayed
put in Arkansas City, Arkansas, a
town long at the mercy of the great
river, even as others abandoned it.

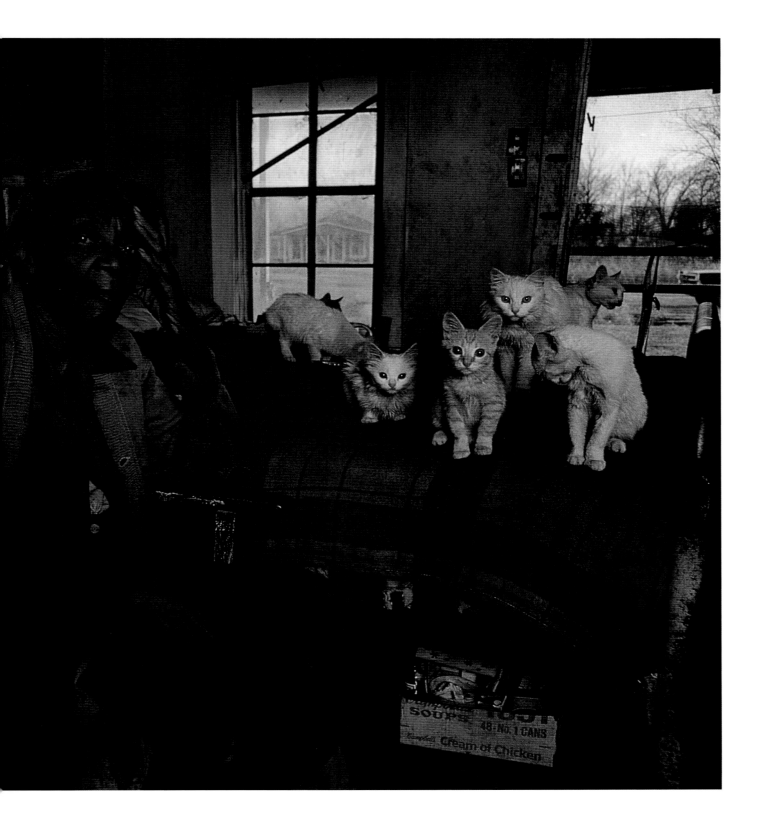

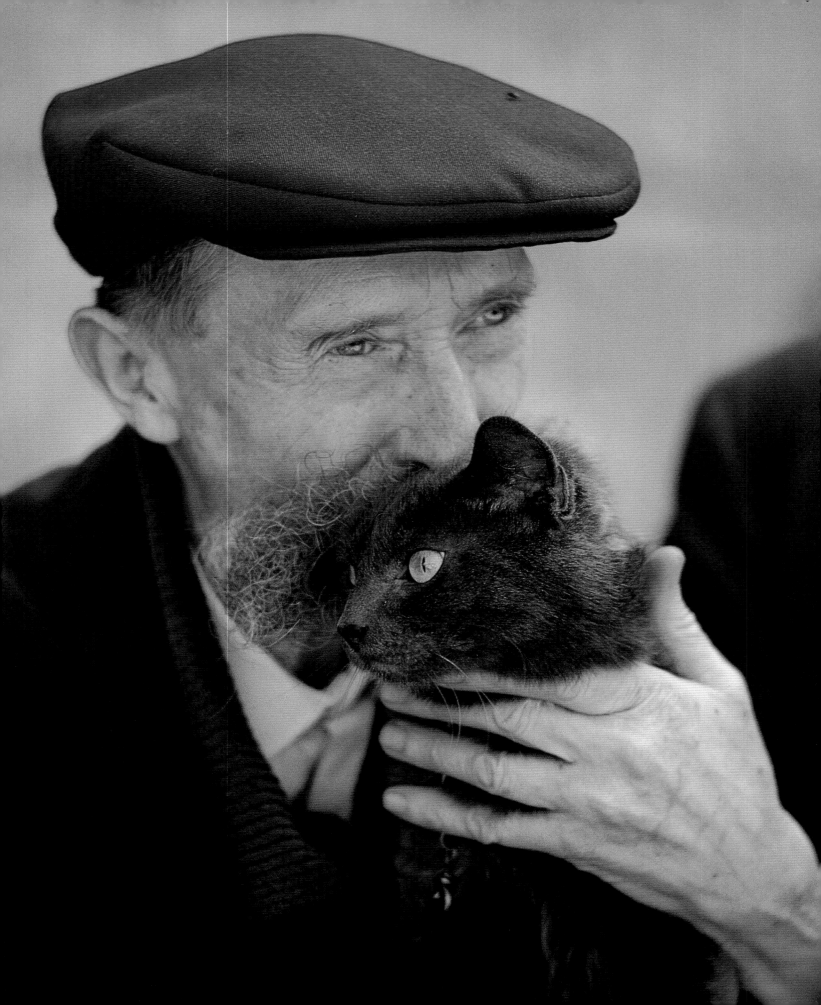

Bruce Dale
FRANCE ~ 1967

Monsieur Henri Thomas cuddles
his cat Nicolas, who accompanied
him each day from his home on
Paris's Left Bank to a small park on
the Île de la Cité. There, the patient
Nicolas would amuse himself while
his master played cards with friends.
"The cat is a dilettante in fur," the
French poet Théophile Gautier
once dryly observed.

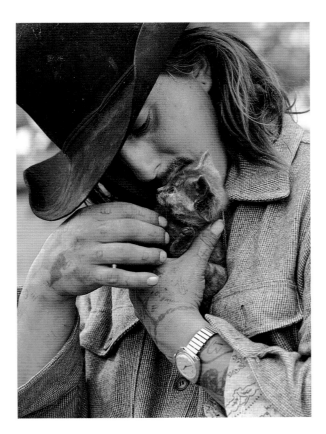

Sisse Brimberg
WASHINGTON ~ 1977

Sisse Brimberg was exploring
Washington's Yakima Valley when
she caught Steve Oldcoyote, a South
Dakota Sioux cowboy pausing to
reveal the gentler side of a man
sporting a "Lone Wolf" tattoo. He
seemed to agree with the sentiment,
"The smallest feline is a master-
piece"—a pronouncement attributed
to Leonardo da Vinci.

Chris Johns
FLORIDA ~ 1993

Centenarian Marjory Stoneman
Douglas was regarded as an
environmental saint because of
her tireless efforts to preserve
Florida's Everglades. Comments
photographer Chris Johns, "She was
just this incredibly gentle, soft-
spoken, thoughtful lady. We were
sitting there talking about the fate of
the Florida panther, when her own
cat jumped up on her lap."

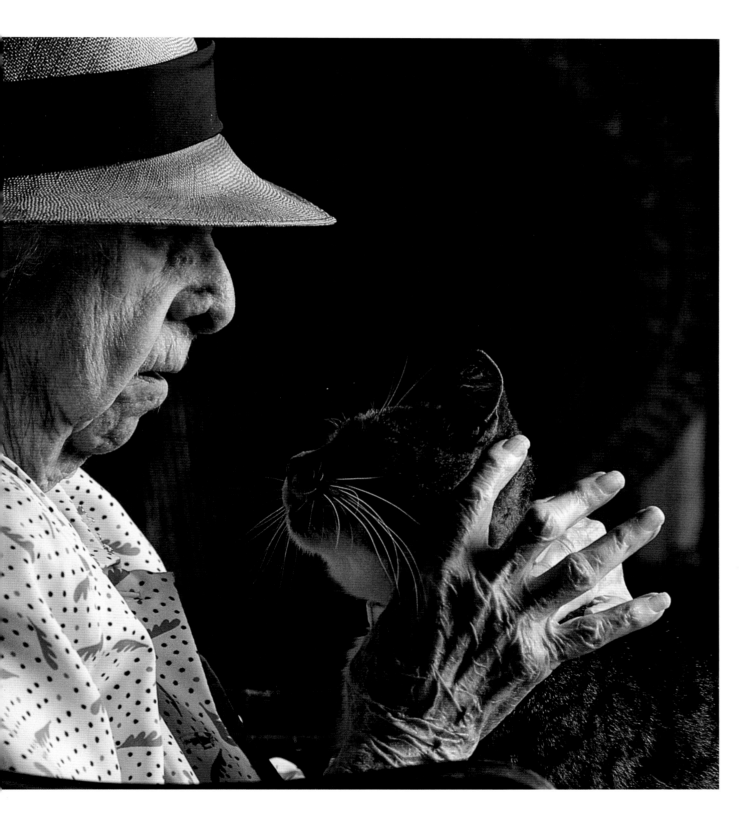

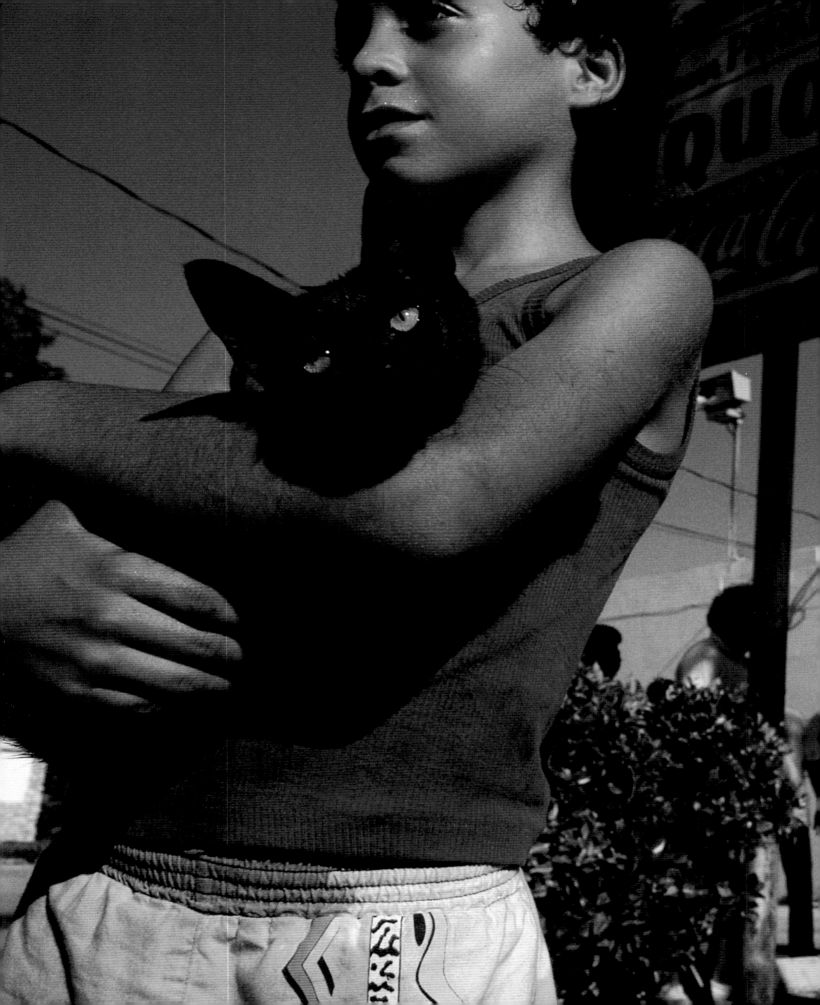

Maggie Steber
FLORIDA ~ 1991

[*Preceding pages*] Maggie Steber had pulled over to watch an empty car burning on a busy corner of Biscayne Boulevard in Miami. "The scene was so colorful, with the flames and all the traffic and the palm trees. But then I saw these two boys with their cat—the sun making its eyes sparkle—and decided it was just more interesting. 'Wasn't the kitty afraid?' I asked them. No, they said, they took it everywhere. And it was amazing, really, that the cat was so calm because the whole affair was really quite a fracas."

George F. Mobley
INDIA ~ 1970

While exploring nomadic lifestyles for the book *Nomads of the World*, George Mobley came across this dusty toddler and cat in northwestern India. The Gaduliya Lohars are an ancient tribe of wandering Hindu artisans; the jewelry seen here displays their skills at metalwork. "There are plenty of wild cats, tigers and lions, there in Rajasthan," Mobley recalls. "But the Gaduliya Lohar are a very poor segment of a very poor society, and the sight of this pet cat seemed unusual to me. I was moved."

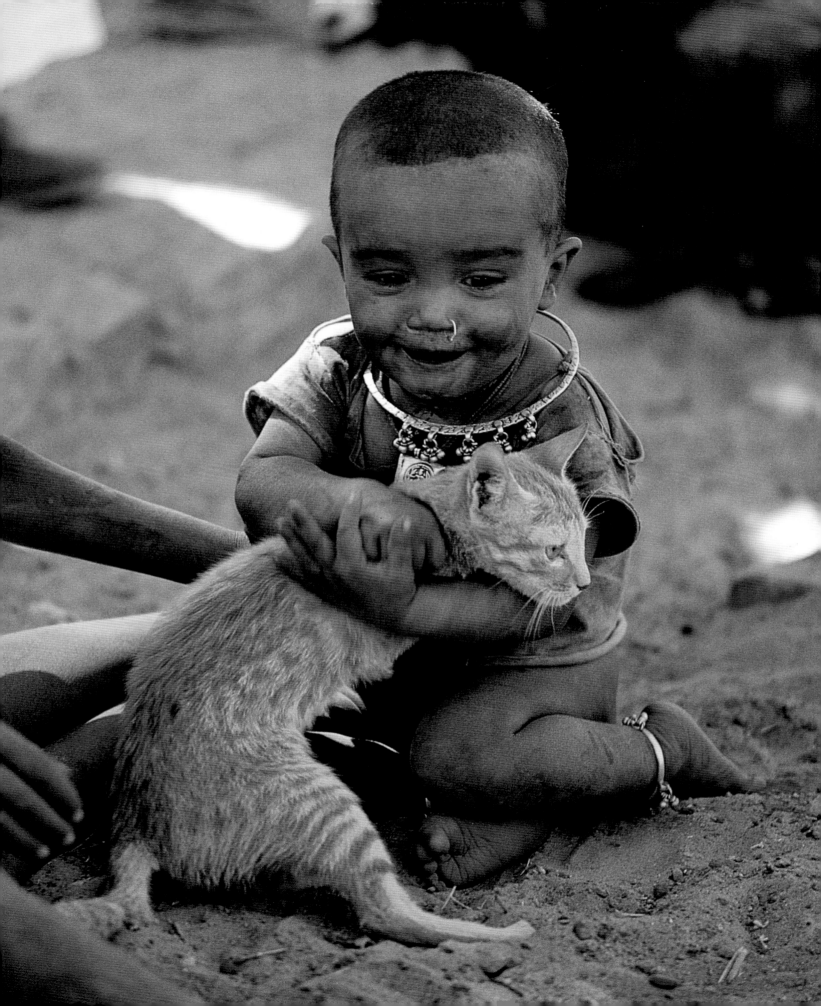

Bill Luster

PENNSYLVANIA ~ 1993

Bill Luster was watching a horse-training session near Aaronsburg, Pennsylvania, when he noticed Zack Flick scrunching up his face. Cats' tongues are scratchy—the better to groom themselves with—so a little licking can soon start to feel like animated sandpaper on the cheek. Wrote T. S. Eliot, "When a Cat adopts you there is nothing to be done about it except to put up with it until the wind changes."

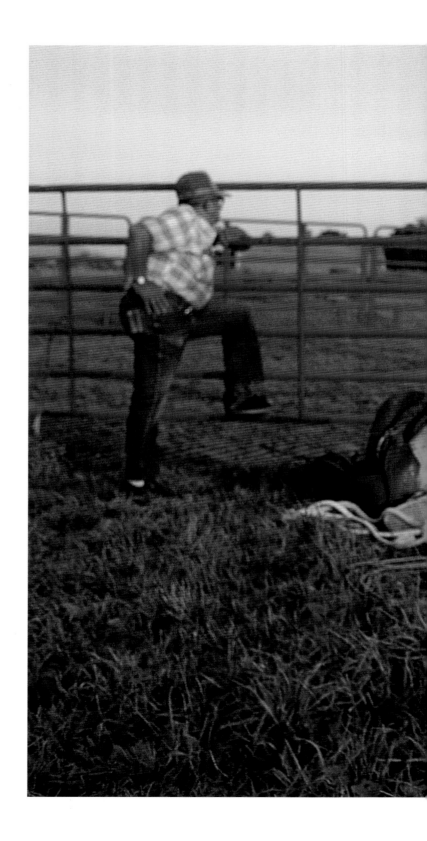

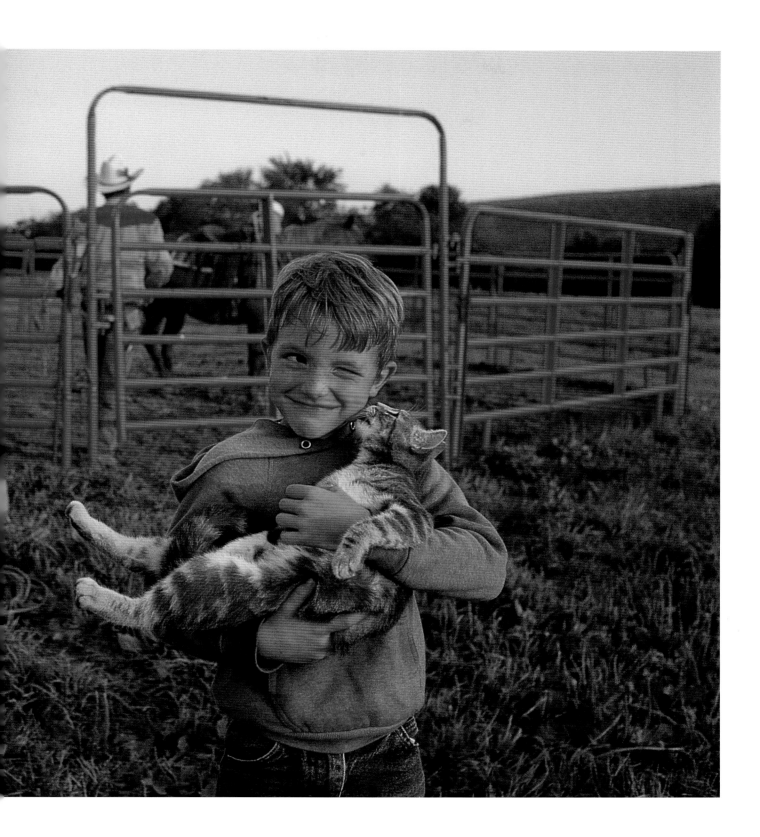

Bruce Dale
ARIZONA ~ 1997

While passing through White
House, Arizona, a place he remem-
bers as a "ghost town," Bruce Dale
spotted this vigilant figure peering
out from an abandoned building.
"I was told it chased the rattlesnakes
living under the house," he says in
an admiring tone. In numerous
mythologies, from those of ancient
Egypt to the Norse sagas, cats and
serpents are linked. Oscar Wilde, in
a memorable phrase, once chose to
describe a cat's curved and flicking
tail as "a monstrous asp."

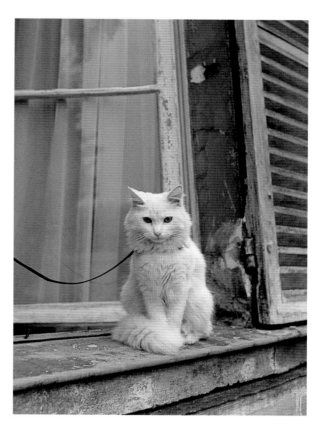

Bruce Dale
FRANCE ~ 1967

French statesman and man of letters
François-Auguste-René de Cha-
teaubriand once wrote, "The cat
lives alone, has no need of society,
obeys only when she pleases, pre-
tends to sleep that she may see the
more clearly, and scratches every-
thing on which she can lay her paw."
Apparently the owner of this cat—
photographed by Bruce Dale on
Paris's Île de la Cité—has, despite
her pet's demure expression,
heeded her countryman's words,
deciding a leash was the answer.

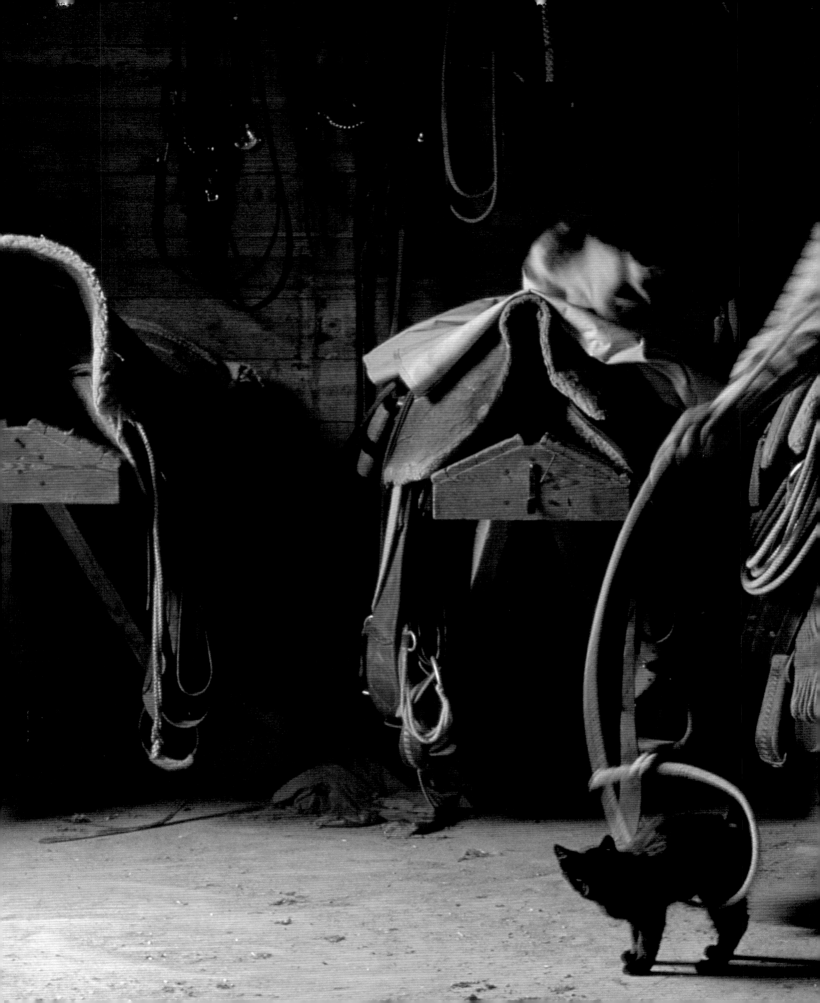

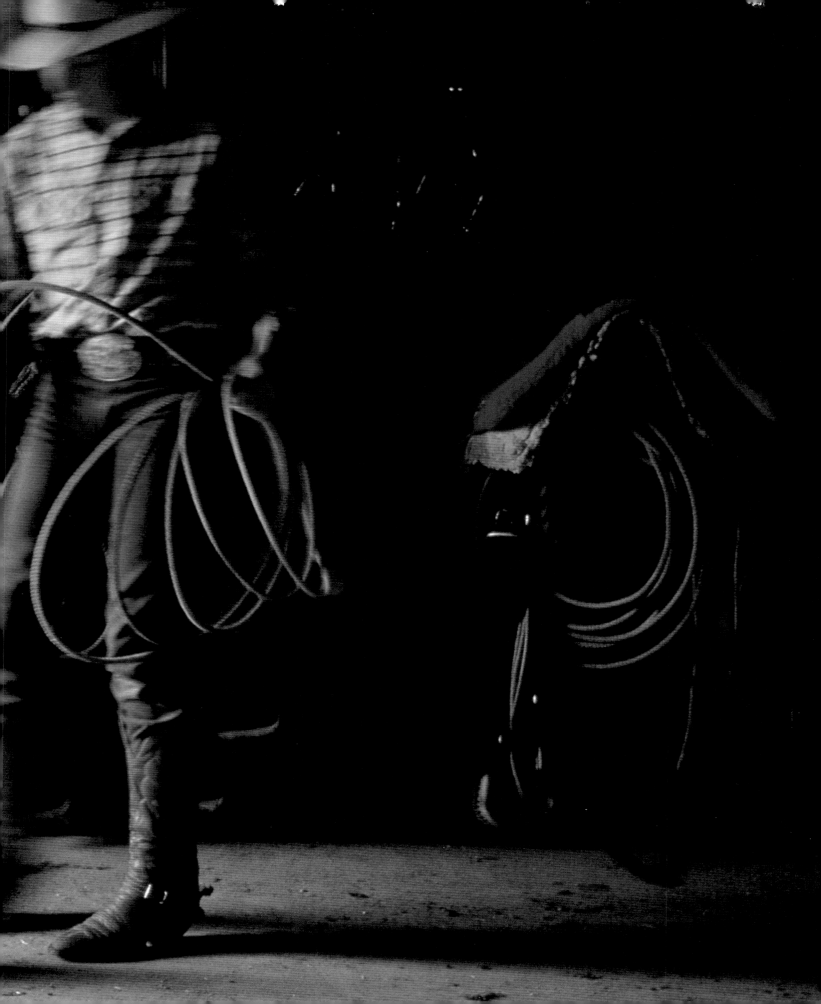

Joel Sartore
TEXAS ~ 1990

[*Preceding pages*] "I'm always grateful when these things just *work*," admits Joel Sartore. With the tripod set up for a portrait, the photographer was standing around, talking to a young cowboy. Then a black kitten scampered into view. "The guy was goofing around with the cat, swishing his lariat—he did it once and I got one frame." The setting is the Cross H Ranch near Post, Texas, a town built from the ground up in 1907 by C.W. Post, the cereal magnate.

William Albert Allard
MONTANA ~ 1972

This barn cat spotted by Bill Allard had a typically active life, or so the photographer attests, on a ranch near Bearcreek, Montana. Farm cats, supposedly, can range over as much as 150 acres; Padlock Ranch, however, covers a quarter of a million acres.

Bruce Dale
COLORADO ~ 1972

One could say that this little black
stray is at the end of its rope, with
the affable Shorty Sutton looking
on. Found outside Williams Cafe,
in the old railroad town of Minturn,
Colorado, it had no notion it was
being immortalized by Bruce Dale.
As Oliver Herford, an English
writer and illustrator, once rhymed:

Gather kittens while you may,
Time brings only sorrow;
And the kittens of today
Will be old cats tomorrow.

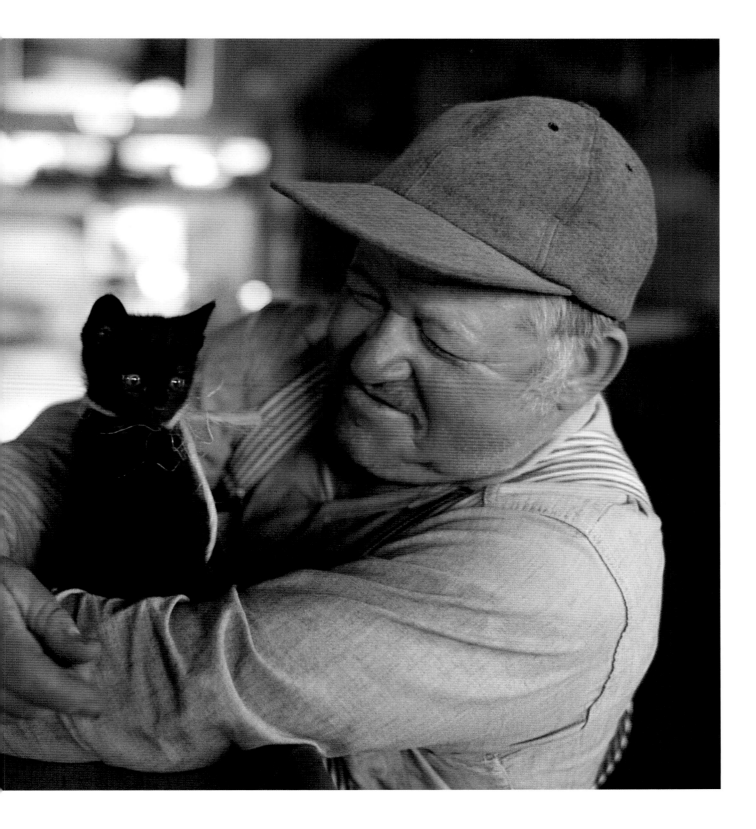

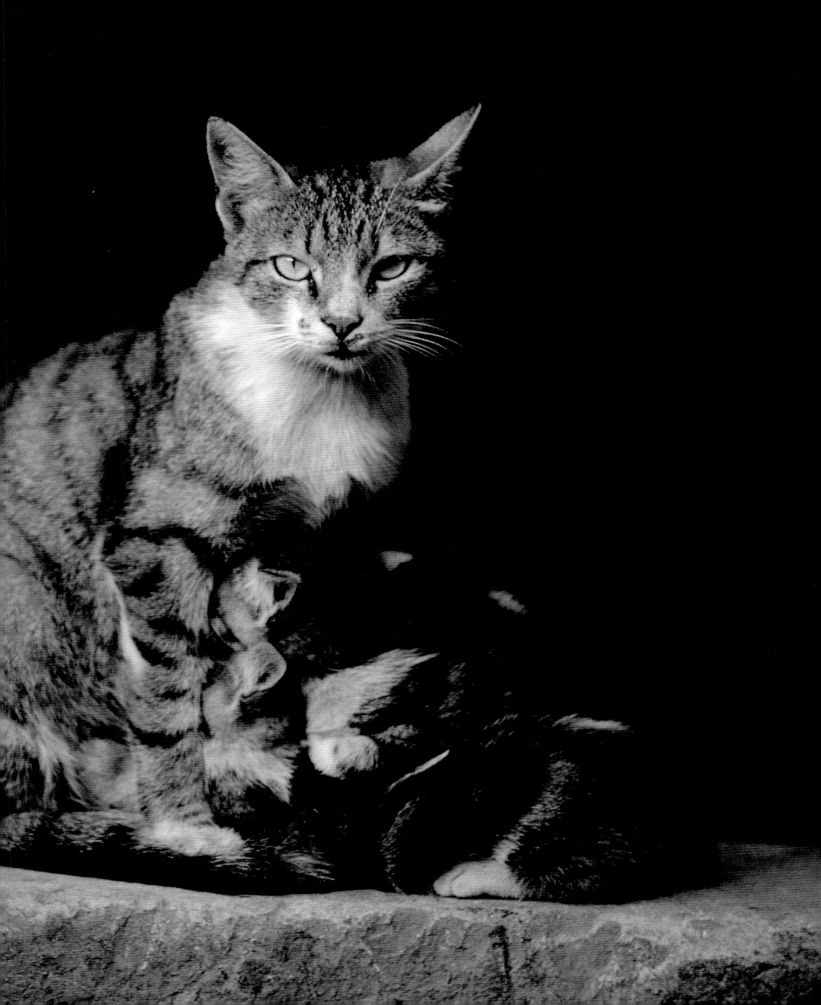

Bruce Dale
TURKEY ~ 1969

[*Preceding pages*] This feline portrait, with old masterlike richness, was shot in Istanbul, Turkey, by Bruce Dale while on assignment for *Gypsies: Wanderers of the World*. It calls to mind a tender description penned by English novelist Sylvia Townsend Warner. "I wish you could see the two cats drowsing side by side . . . their paws, their ears, their tails complementally adjusted, their blue eyes blinking open on a single thought of when I shall remember it's their suppertime. They might have been composed by Bach for two flutes."

Bruce Dale
WYOMING ~ 1972

Cat and conveyance definitely appear to be cut from the same mold here. Having seen better days, they are, like T. S. Eliot's Growltiger in his poem *Growltiger's Last Stand*, a bit "torn and seedy." Yet somehow the essential dignity of each remains intact. Bruce Dale shot the picture at Sam Yetter's sawmill in Meeteetse, Wyoming, while working on the book, *American Mountain People*.

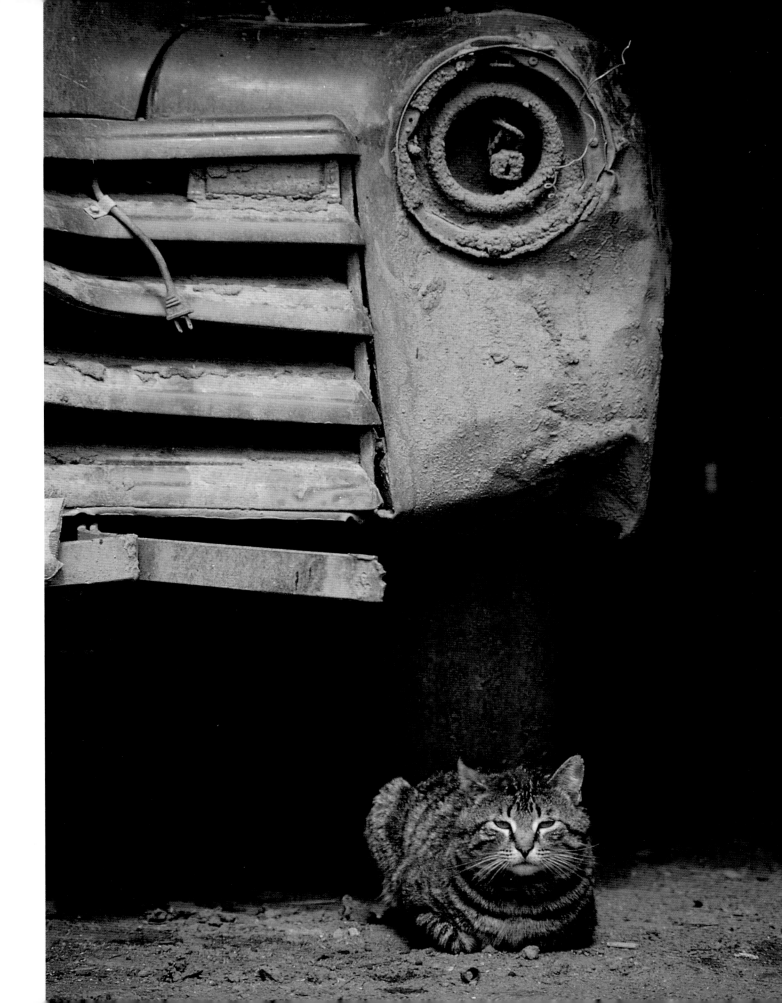

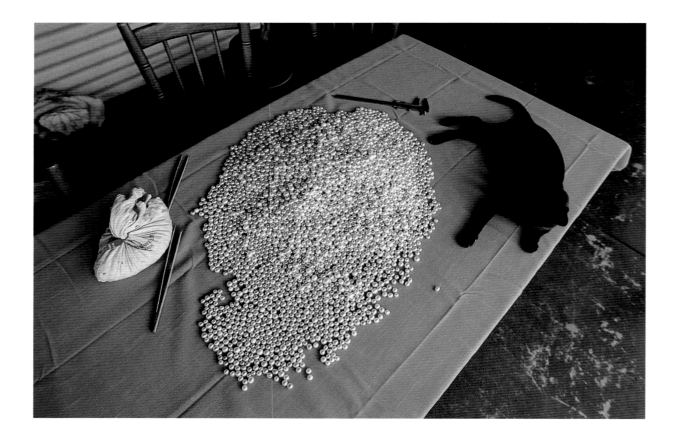

David Doubilet
AUSTRALIA ~ 1989

The pearl industry is what drew David Doubilet to Broome, Australia, an old pearl port on the country's northwest coast. "It was the first major harvest for pearlers Judy Arrow and her brother Stephen after five years' work—and it's incredible backbreaking labor." He pauses, "There's probably about ten thousand dollars' worth of pearls laid out here, and this cat comes running along. Before I took the picture it'd played with one, very carefully chosen, batting it back and forth with its paw."

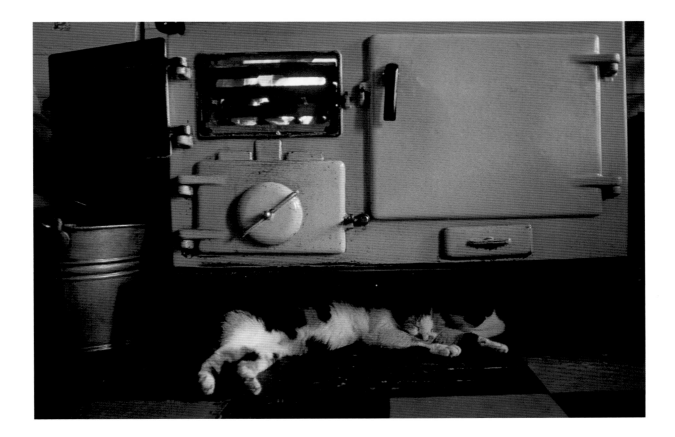

Susie Post

Inishmore, largest of the Aran
Islands lying off Ireland's western
coast, is, according to Susie Post,
a "stronghold for old Irish tradi-
tions—you see moments that you feel
could be taking place a hundred
years ago. The past and present are
rammed so close together." Post,
who admits she is "a total cat lover,"
mentions that twins had just been
born to the family whose cat is
enjoying its fire-warmed dreams—
a visual ode to domestic peace.

Photographer Unknown
AT SEA ~ 1935

In this unattributed 1935 photo
acquired for the National
Geographic Society's picture
archives, a ship's cat apparently
shares the same snug accommoda-
tions as its human bunkmates.
Probably the most renowned ocean-
going feline is Edward Lear's fic-
tional Pussy-Cat, who sailed off with
the Owl on a matrimonial voyage in
a "beautiful pea-green boat." But
there was also the unsinkable Tom,
real-life ship's cat on the U. S.
battleship *Maine,* who survived that
vessel's destruction in Havana
harbor in 1898, a tragedy that
claimed the lives of 260 people.

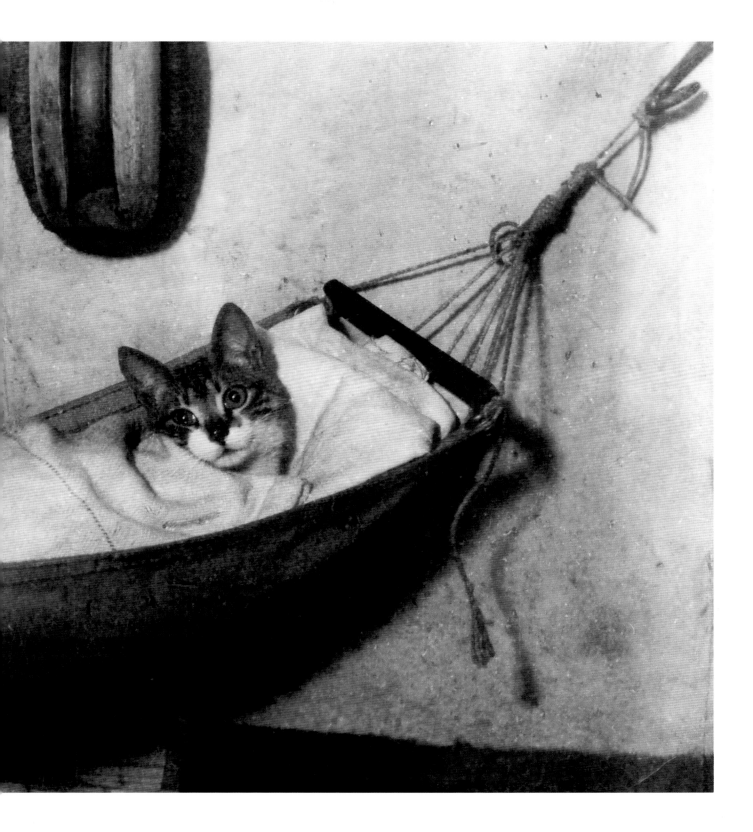

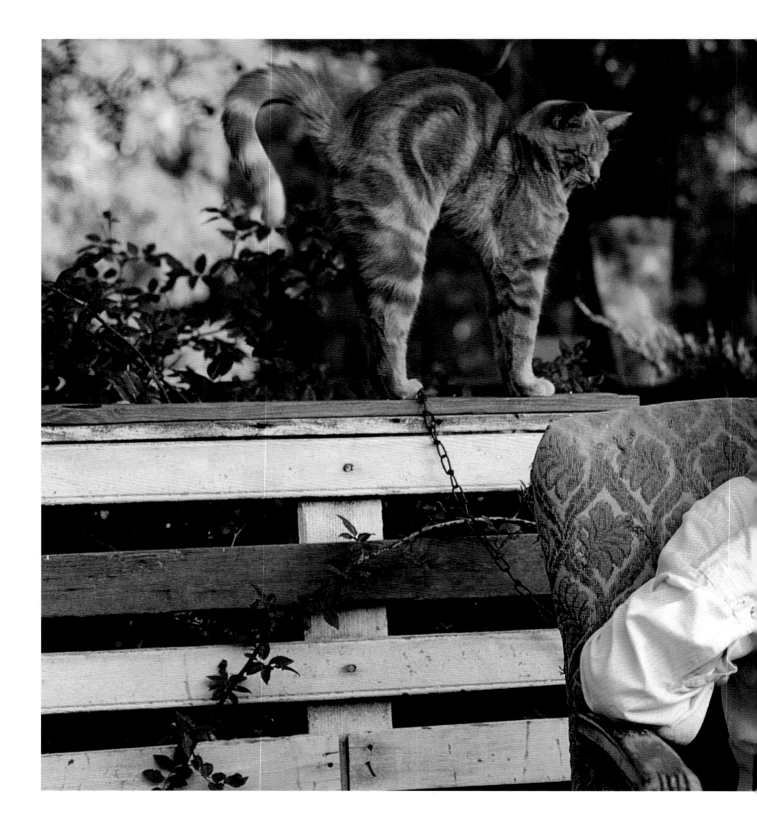

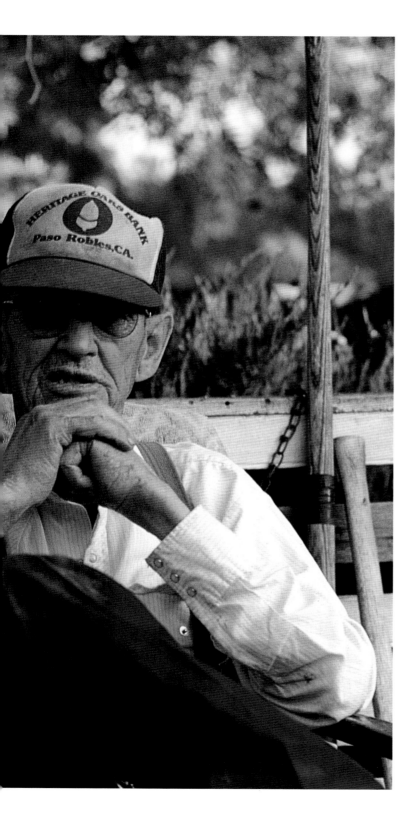

James L. Stanfield
CALIFORNIA ~ 1985

A major fault line runs directly below Parkfield, California. At the time this photo was taken by Jim Stanfield, 87-year-old Buck Kester, a Parkfield native, had been through 6 earthquakes. Some experts conjecture that cats are sensitive enough to be able to predict not only quakes but also volcanic eruptions and severe electrical storms. "It always gives me a shiver when I see a cat seeing what I can't see," noted poet Eleanor Farjeon.

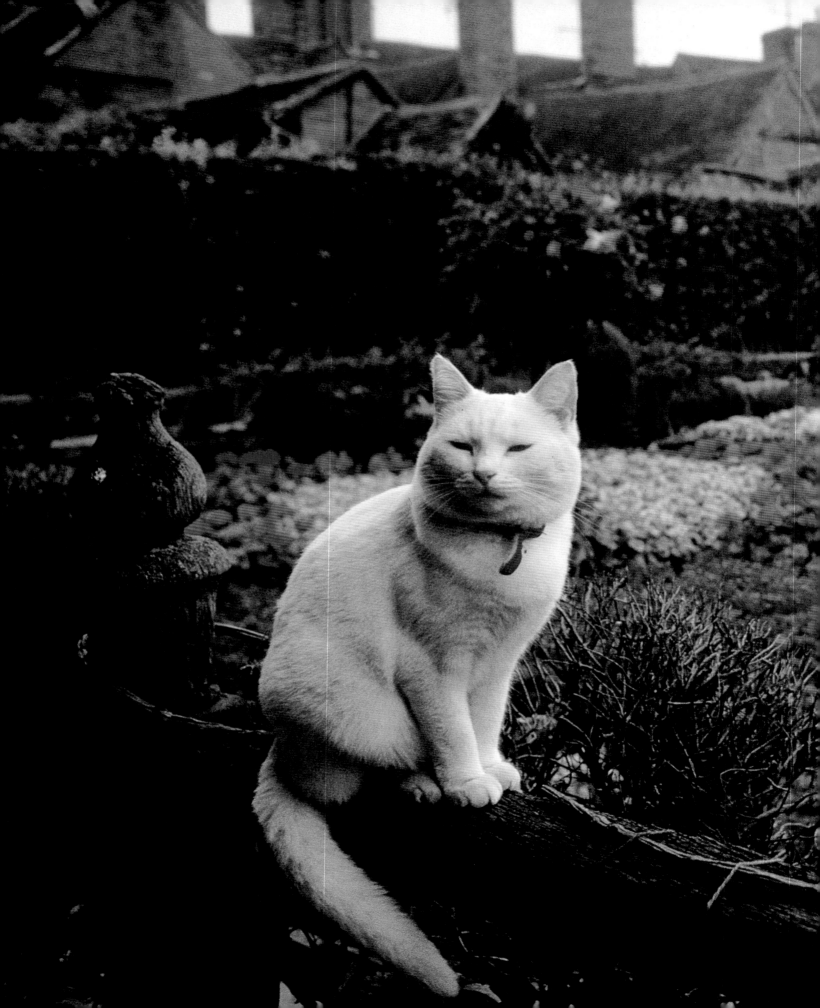

Sam Abell
ENGLAND ~ 1980

[*Preceding pages*] "I am as vigilant as a cat to steal cream," boasts Falstaff in *Henry IV, Part I*. And the brilliantly colored garden of Shakespeare's home in Stratford-upon-Avon makes a fitting backdrop for the creamiest of watchful white cats, who sat for this portrait by Sam Abell.

Karen Kuehn
NEW YORK ~ 1996

Judging from this Russian Blue kitten's wary glance upward, a dancer's legs are virtual skyscrapers—that is, if you happen to be no larger than a toe shoe *en pointe*. The breed of cat chosen by Karen Kuehn is appropriate to the birthplace of the legendary émigré who inspired the photo: "I was thinking of the great choreographer George Balanchine. He was famous for throwing a cat into the air when he wished to demonstrate to his ballerinas how to land perfectly on one's feet."

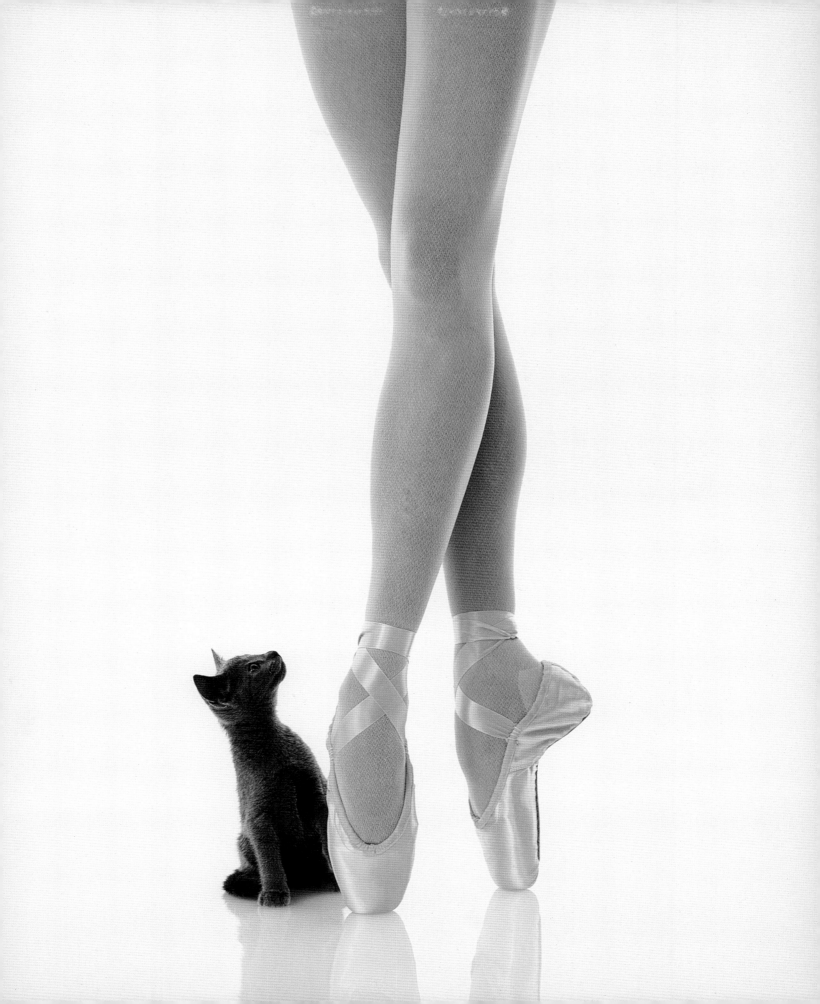

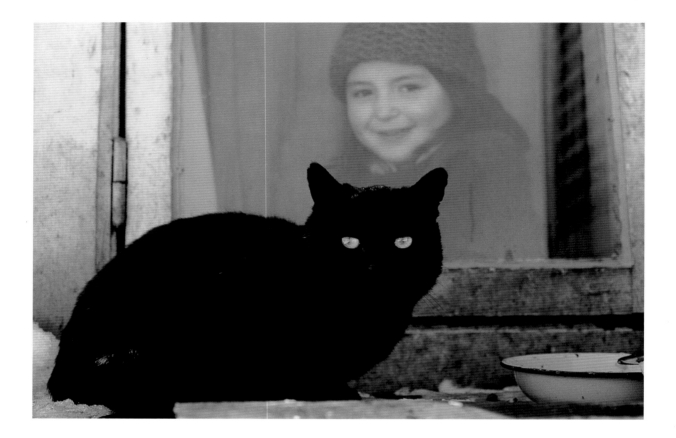

James L. Stanfield
CHILE ~ 1967

It was a bitterly cold day in Puerto Williams, a town on the north side of Isla Navarino, off the tip of Chile. Jim Stanfield remembers, "Though I was trying to fly out, I'd gotten snowed in. With nothing to do, I was a little bored and just found myself roaming the area. It must have been about 0°F. In my mind what I thought was, 'Here's this little girl watching me and wondering what kind of crazy idiot I am to be outside in that kind of weather, taking pictures of a cat.' "

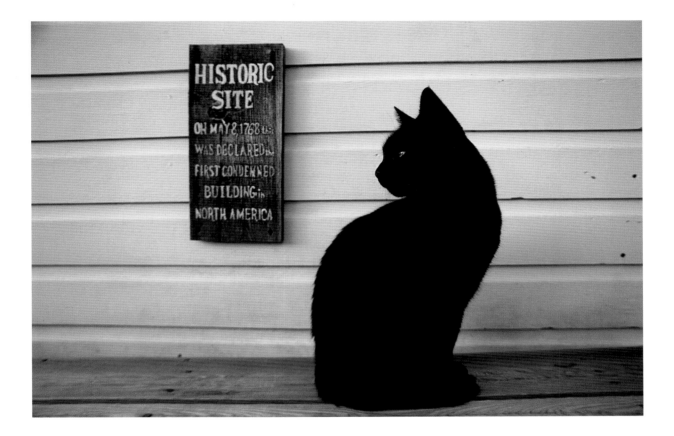

Richard Olsenius
WASHINGTON ~ 1995

On the main street of Coupeville,
an old fishing village on Whidbey
Island in Puget Sound, this cat was
keeping watch when photographer
Richard Olsenius happened by.
Black cats have something of a bad
reputation when it comes to the
question of luck, but there is a
Scottish saying, "A strange black cat
on your porch brings prosperity."

Bruce Dale
CALIFORNIA ~ 1972

Photographed by Bruce Dale as part
of the *American Mountain People* project,
the fetchingly posed cat Goldie
spent her days on a farm near
Kelsey, California. "Dogs remem-
ber faces, cats remember places,"
goes an old saying; unfortunately,
says Dale, Goldie's owners, the
Griffiths, were being forced to sell
out after more than 120 years of
continued family stewardship and
cultivation of the property.

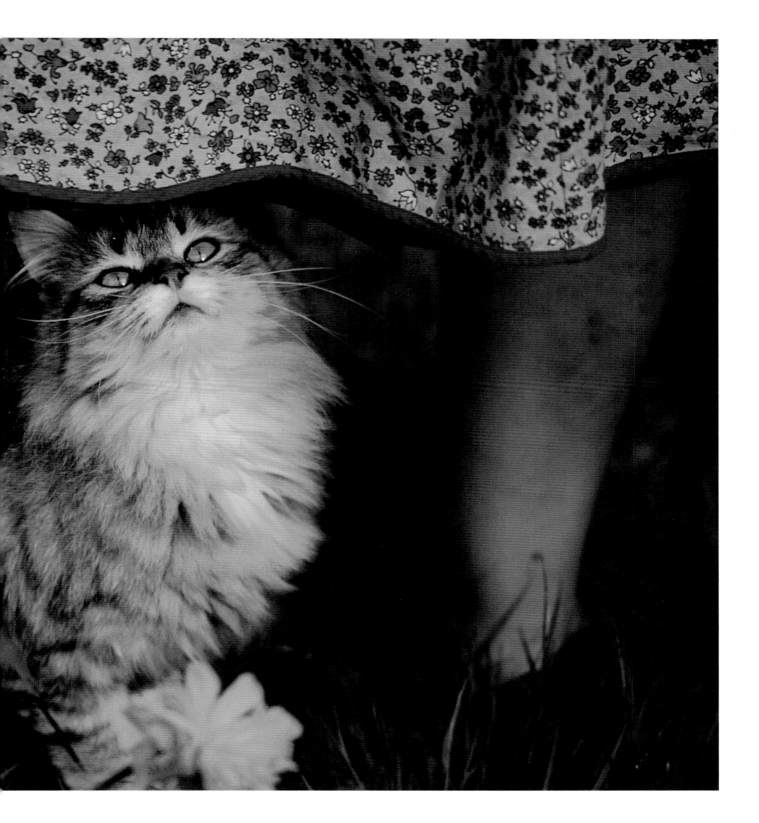

Bernard Wolf

Bernard Wolf made this image so dramatically punctuated by a black cat in elegant motion while visiting the Algarve region of Portugal. "It was early morning and I was photographing women hanging out laundry when all of a sudden the cat leaped onto the wall." Such ability to swiftly and decisively transform a scene illustrates the observation once made by French statesman and writer Raymond Poincaré that a cat will always know "how to do precisely the right thing at the right moment."

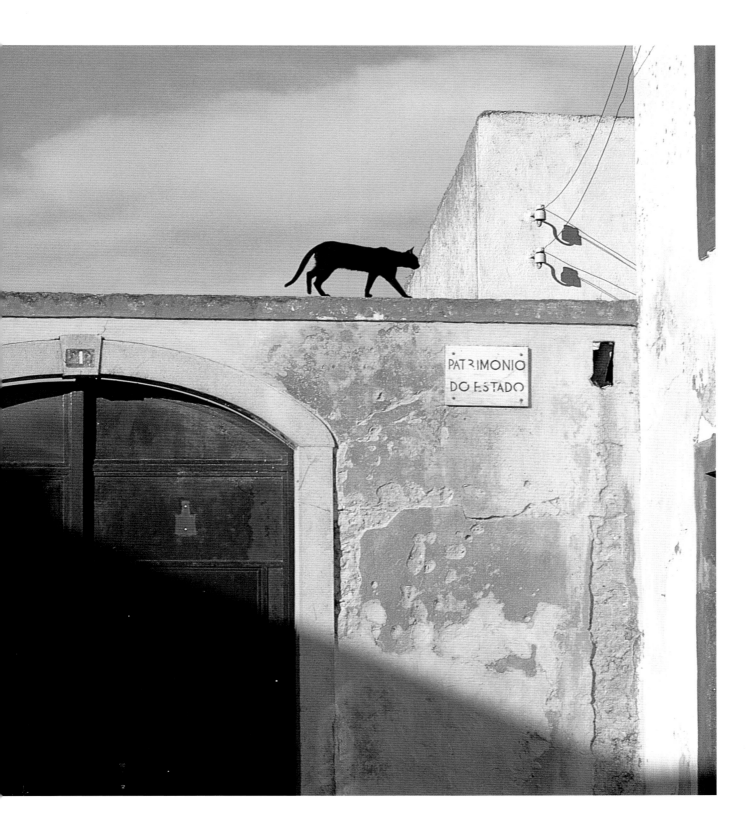

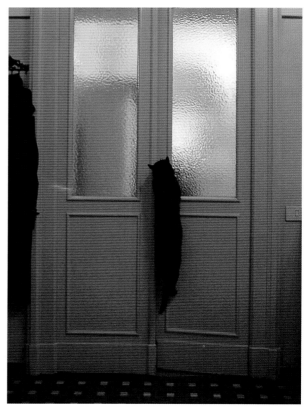

James L. Stanfield
VATICAN CITY ~ 1991

The Vatican Swiss Guards have
served as the Pope's personal
bodyguards since 1506. Recognizing
that even an army as small as this
one runs on its stomach, Jim
Stanfield decided to spend a full
day observing and photographing its
cooks. "We were in the dining
area, with a door leading to a huge
kitchen, and, all of a sudden, the
nun I was with laughed and asked
me, 'Did you ever see anything
like this?' " Stanfield watched as a
black cat ("its name was Ramble, and
it was a stray adopted by the Guards
as a mascot") proceeded confidently
on its own into the kitchen to sniff
out the day's menu.

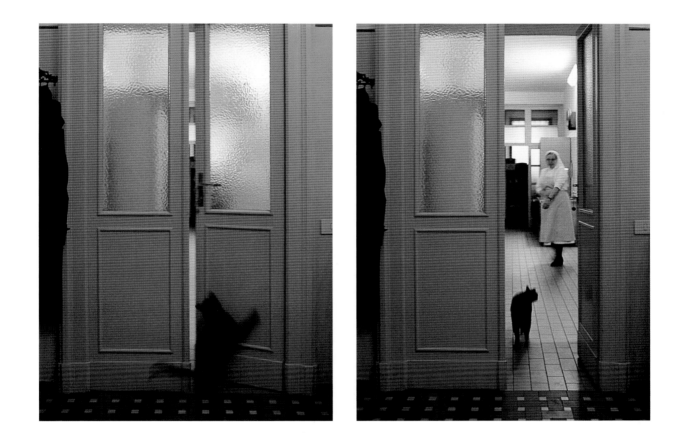

Bruce Dale

COLORADO ~ 1972

Bruce Dale photographed this
screened-in cat near Central City,
Colorado, while on the road for the
book, *American Mountain People*. Its
cloistered, contemplative aspect
evokes the words of Sir Walter Scott:
"Cats are a mysterious kind of folk.
There is more passing in their
minds than we are aware of."

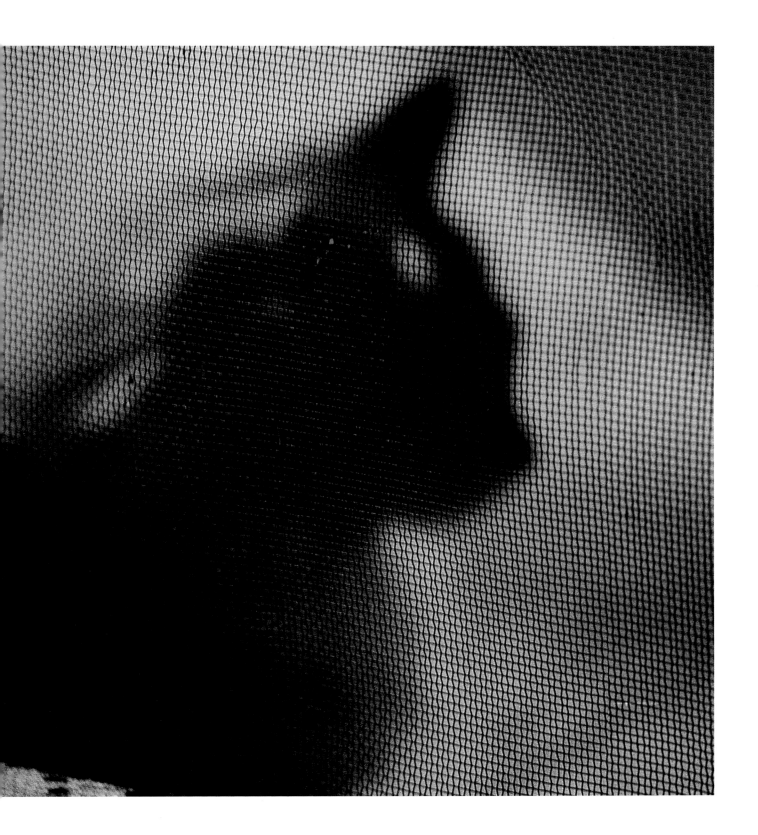

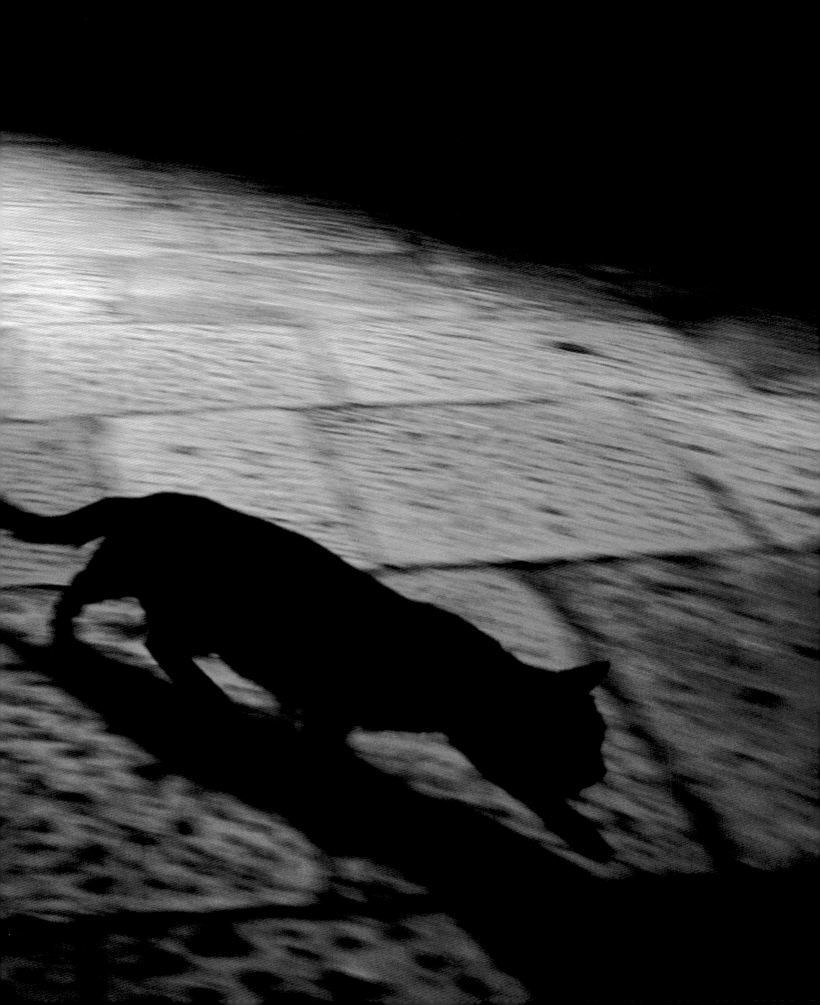

William Albert Allard
ITALY ~ 1994

[*Preceding pages*] It was late afternoon in the Sicilian capital of Palermo, and Bill Allard was roaming around the back stalls of the Vucciria, the city's largest market. When this black cat streaked past—all sinewy shadow, intent on its destination—the photographer took advantage of the eerie power of the moment.

Robert W. Madden
HAWAII ~ 1979

"I was looking for ways to talk about the Hawaiian lifestyle, how very laid-back and simple it was, and to show their love of plants and animals." That's photographer Bob Madden, remembering his visit to Kahuka sugar plantation on the north shore of Oahu. "See how the steps are soft and worn." He adds, "Without the cat, it's not a picture. And, in fact, I got only the one shot and then it upped and walked away."

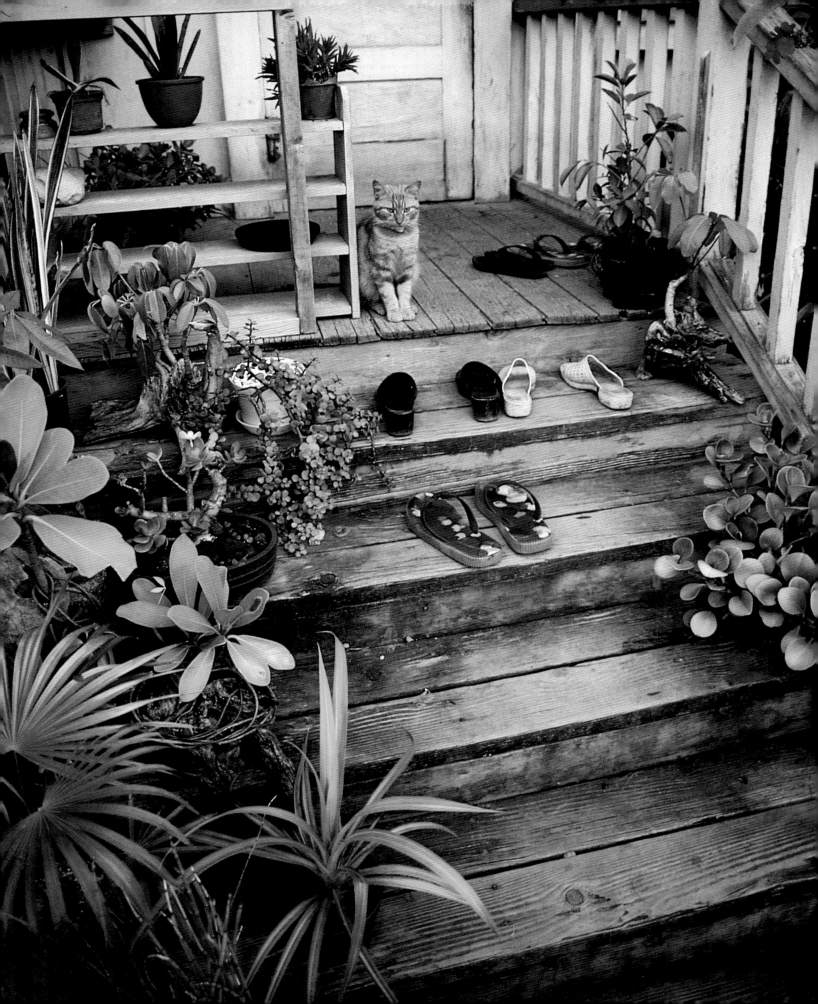

David Alan Harvey
HAWAII ~ 1989

Dave Alan Harvey had flown to Hawaii
to shoot a famous "hula master" when
he paid a visit to Charles "Kindy"
Sproat, cowboy singer and ukulele
virtuoso. "He lived at the end of a road
in Kapaau, on the Big Island, and he
had cats running all over his property.
They were *everywhere*."

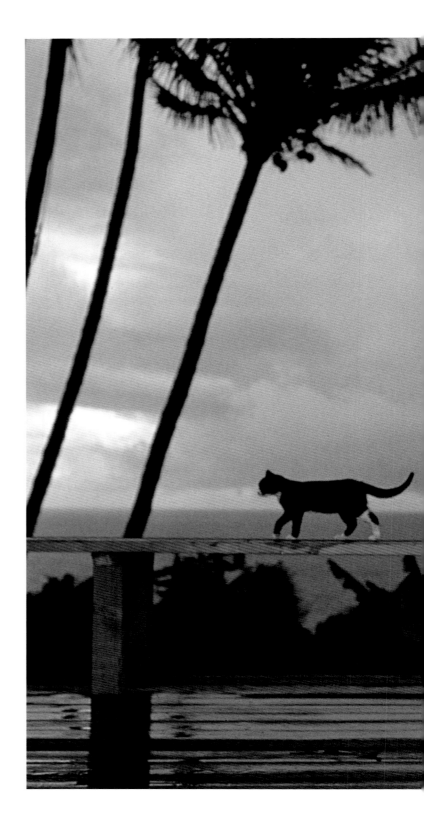

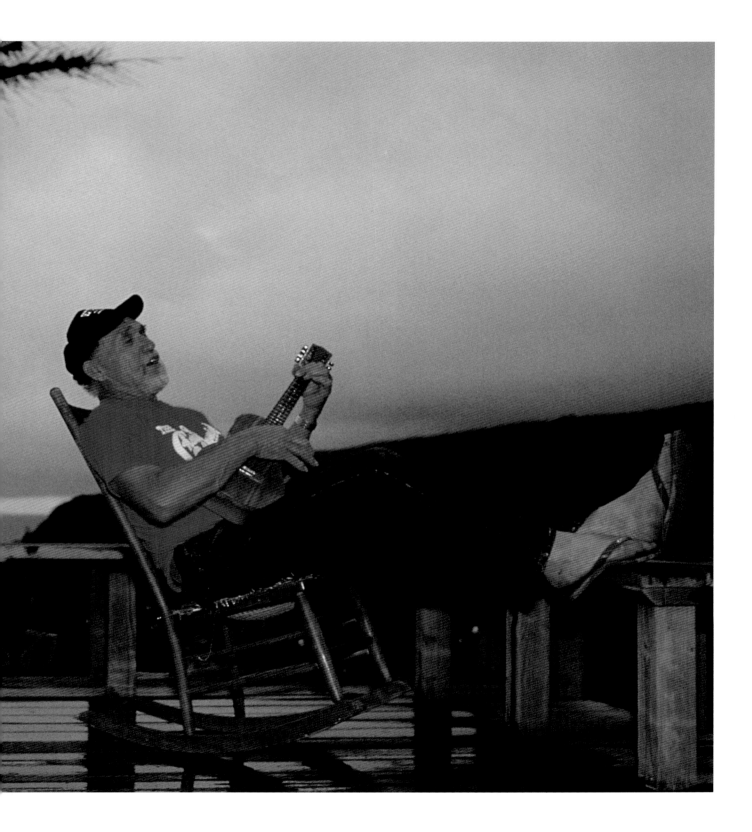

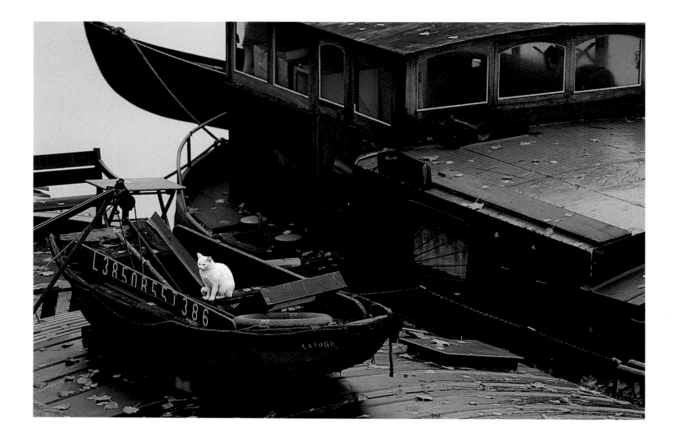

James L. Stanfield
FRANCE ~ 1988

This barge cat on the River Seine
stopped Jim Stanfield momentarily
as he was roaming Paris shooting
images that would evoke the national
essence and capture the scope of the
bicentennial of the Republic. It has
been written, in fact, that the Seine
flows through Paris in the shape of
the arched back of an angry cat.

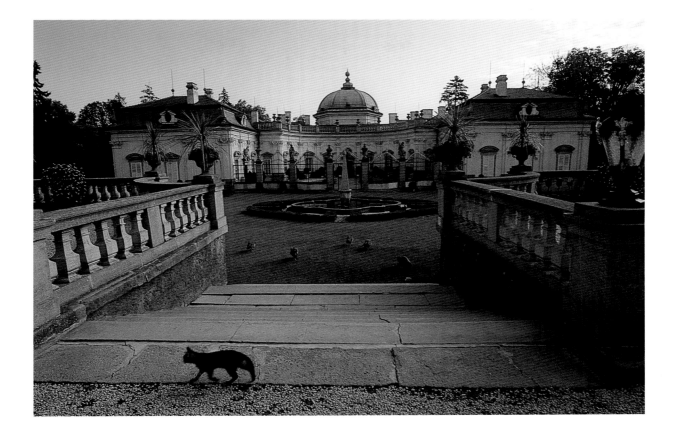

James L. Stanfield
CZECH REPUBLIC ~ 1992

The moated Czechoslovakian castle,
Búcovice, was built in the late 16th
century and is considered one of the
finest Renaissance chateaux in
Moravia. While traveling through
the region, on assignment to docu-
ment just such architectural riches,
Jim Stanfield stopped there long
enough to shoot this cat framed
against the imposing three-storied
courtyard and fountain.

Bruno Barbey

MOROCCO ~ 1985

According to Paris-based photographer Bruno Barbey, the child caught in this shadow-defined moment actually is running away from him, hoping to avoid being photographed. The village of Chechaouene, high in the Rif Mountains of northern Morocco, is a sacred city founded by an Arab prince and fortified against Portuguese and Spanish attack. "For me," says Barbey, "it's easier to photographs cats than people."

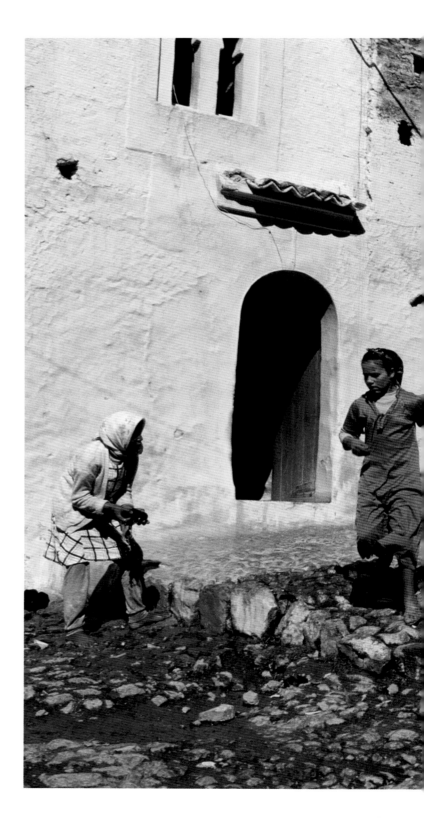

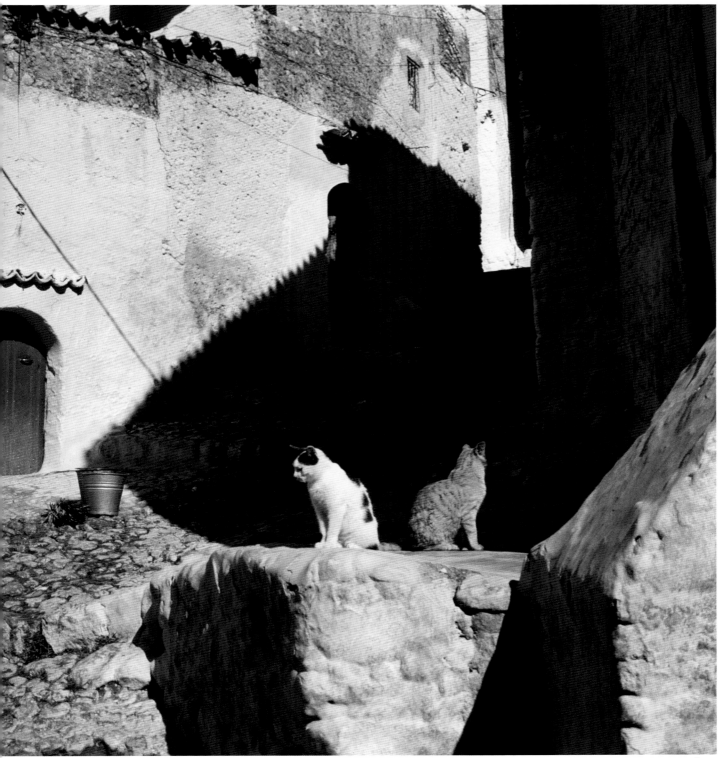

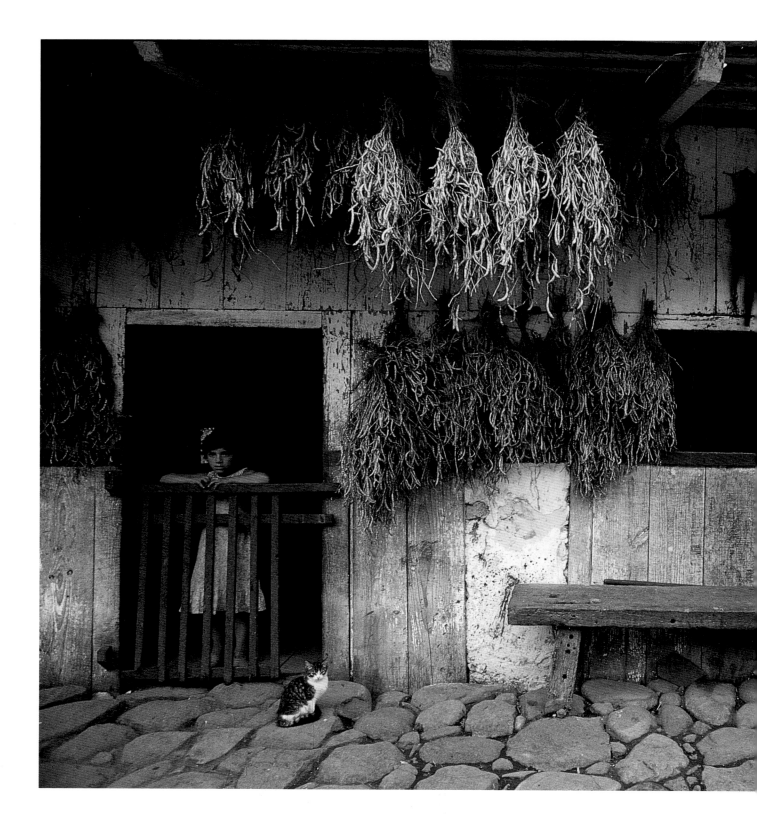

Guillermo Aldana E.
MEXICO ~ 1981

By calendar years, this photograph was taken not all that long ago—in the early 1980s. However, as Guillermo Aldana journeyed on horseback along the Camino Real, he says he felt transported into a timeless past. Near Ixhuacán de los Reyes, "my eye was caught by this beautiful display, and then the kitty showed up. I thought to myself, aha! *that* makes the picture!" The hides nailed to the wall are fox skins, while the drying legumes are probably the black beans for which this Mexican region is famous.

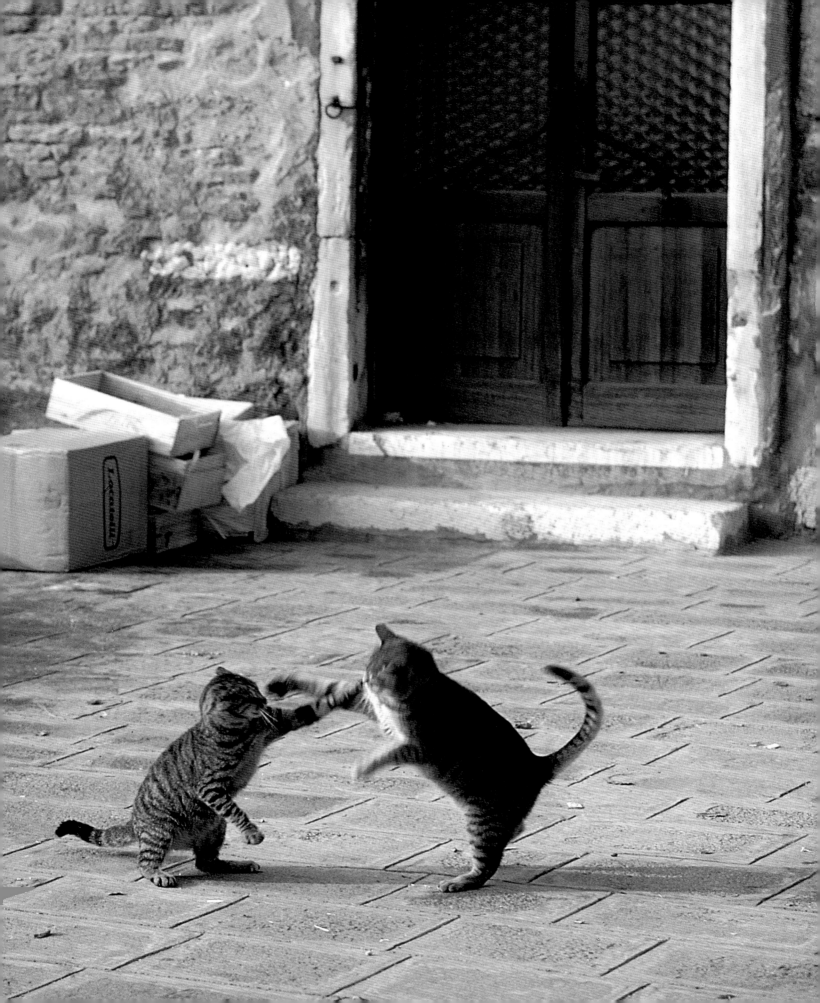

Albert Moldvay
ITALY ~ 1971

[*Preceding pages*] Photographer Albert
Moldvay, who came across this
pair of combative kittens in Venice,
Italy, had a particular fondness for
cats. According to his widow, Erika
Fabian, he once won a ribbon at a
local cat show with his own tabby.
"He washed the cat and put it on
the radiator to dry so all the fur
stood up, and then he brushed it
out to the point where it looked
like an Angora."

Ronald H. Cohn
CALIFORNIA ~ 1984

Koko, a female lowland gorilla
taught to communicate in American
Sign Language, indicated to her
human attendants that she wanted
a cat. (How did she express this
wish? By "drawing" whiskers across
her cheeks with her fingers.) Offer-
ed a stuffed animal, she refused to
be distracted and sulked, stubbornly
holding out for the real thing.
Finally, Koko was presented with a
litter of orphan kittens, one of
which she selected for her pet.
Watching him bounce about, she
named him "All Ball."

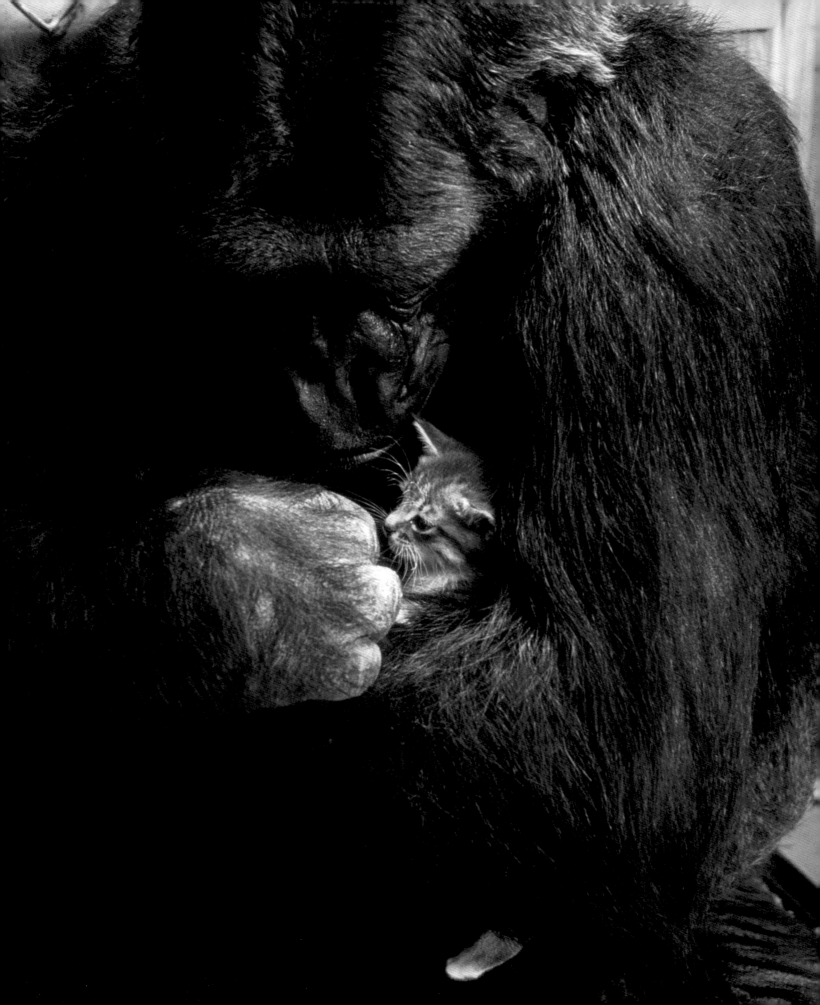

Timothy W. Ransom, Ph.D.
KENYA ~ 1973

Once upon a time in Kenya, a Siamese cat lived in a house in the middle of a baboon preserve. "This was the closest encounter between them that we were aware of," says photographer and animal behaviorist Tim Ransom, who stayed at Kekopey Ranch while working on a project overseen by Shirley C. Strum. The primates—*Papio anubis*, or the olive baboon—were every bit as curious as Balthazar the cat. "There was some fairly high tension at times," Ransom recalls. "The trick was to keep them out and yet not to chase them away."

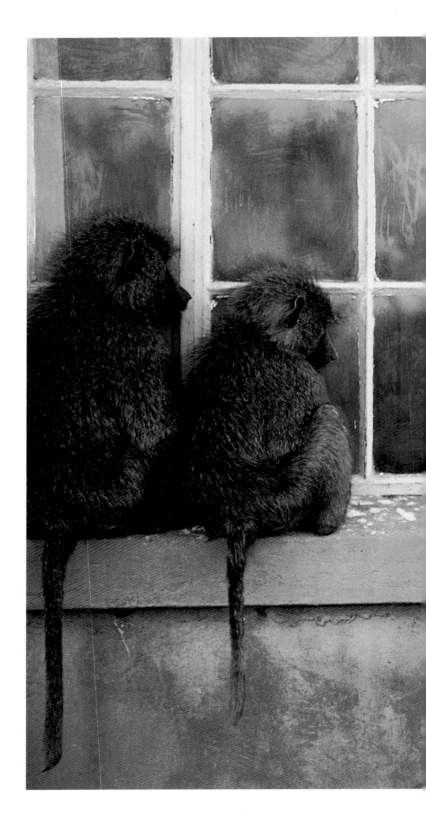

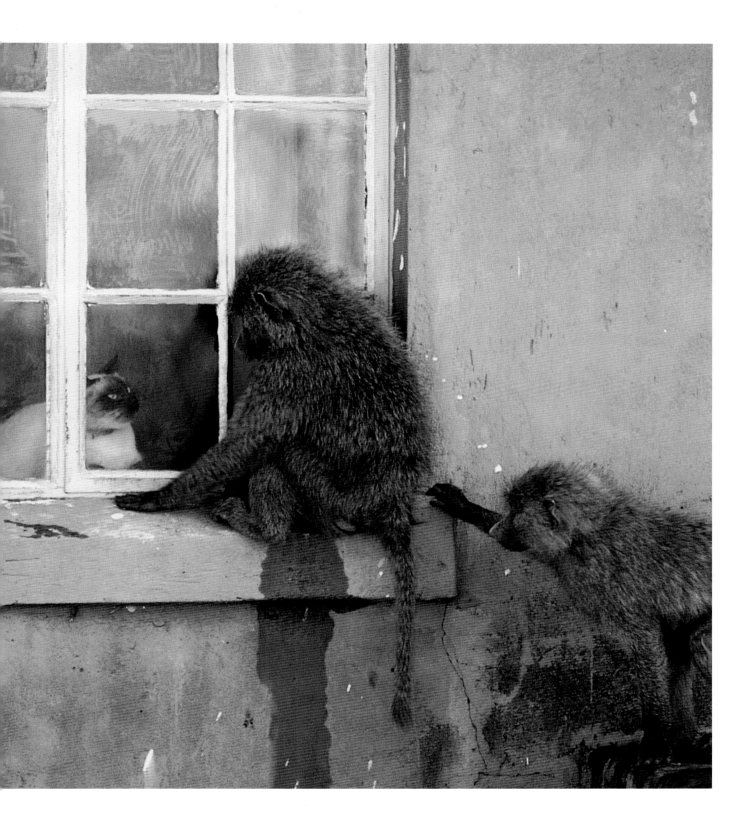

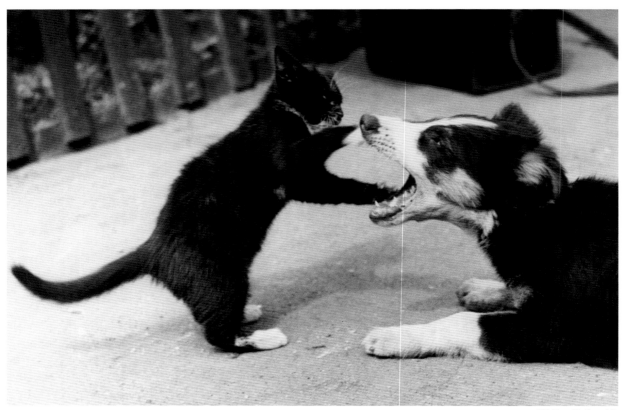

W. E. Meayers
UNKNOWN ~ 1930s

Is this vintage photo by W. E. Meayers
simply a version of a fable by Aesop,
whereby the cat is altruistically
coming to the aid of a dog with a
toothache? Or is it some kind of
feline attempt to exact vengeance on
behalf of those many centuries of
treed ancestors? According to the
information that accompanied its
purchase for the archives more than
60 years ago, the pet couple fea-
tured, in fact, had been raised
together and would frequently "play
in this fashion for hours on end."

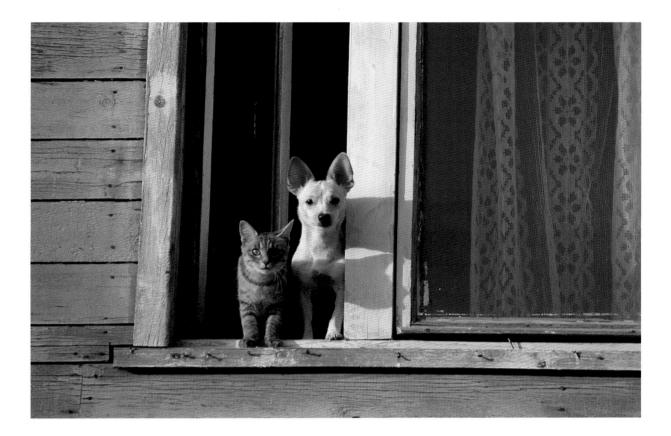

Michael S. Yamashita
JAPAN ~ 1995

Michael Yamashita remembers the
"ghost-town-like atmosphere" of
Yuzhno, in the Kuril Islands off
Japan. "Most people seemed to stay
indoors and there were no public
gathering places, no restaurants,
cafes, or entertainment." This may
explain why the dog and cat seem
riveted by the sight of someone with
a camera.

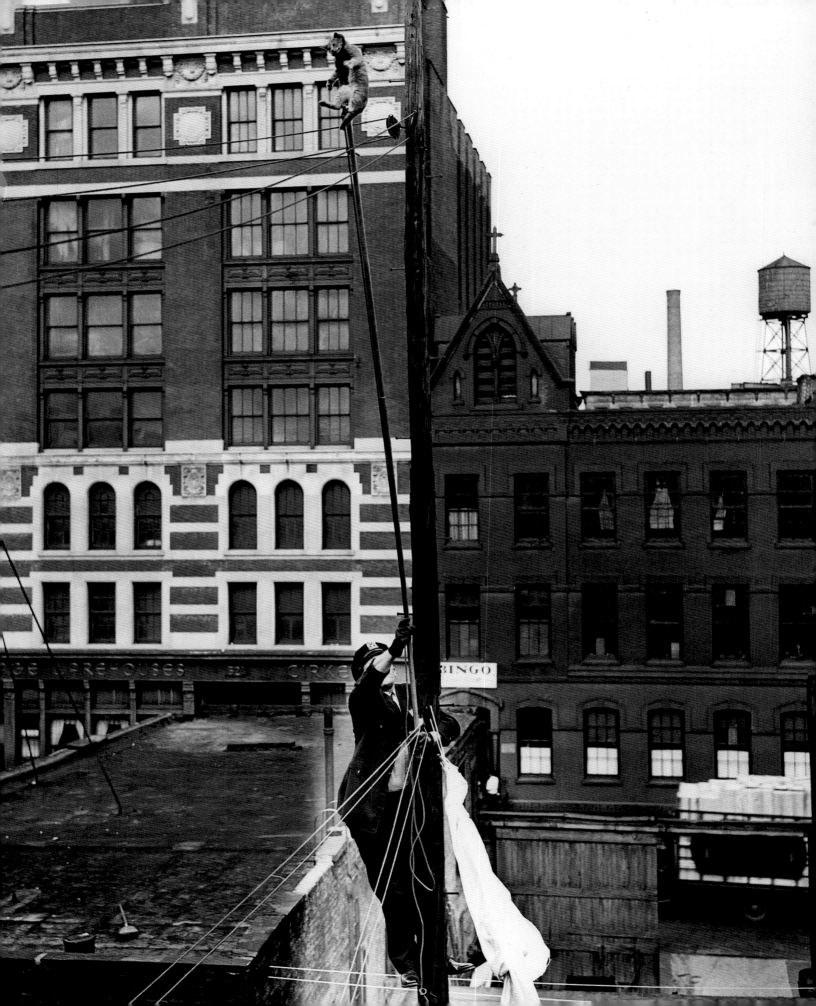

Photographer Unknown
NEW YORK ~ 1937

New York police patrolman Alfred
Miller is one in a long line of
uniformed public servants called
upon to retrieve stranded cats more
adept at climbing up than down.
This 1937 photo was picked up by
the *Washington Post* from the *New York
Daily News*.

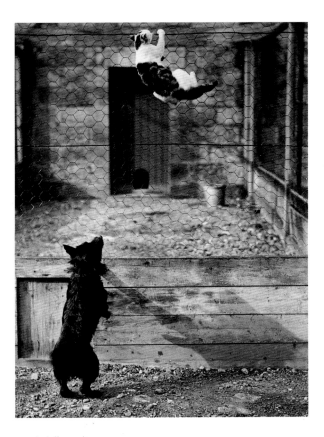

Charles Reid
SCOTLAND ~ 1920

The politician Adlai Stevenson
once wrote, "It is in the nature of
cats to do a certain amount of
unescorted roaming." However, in
this vintage 1920 photograph, here's
a cat that could do with an escort,
and preferably one larger than its
adversary. It is exhibiting its climb-
ing skills in Scotland.

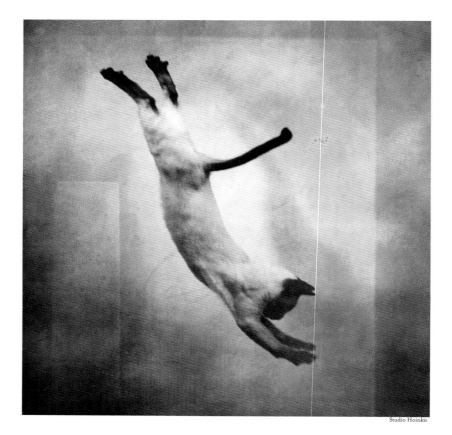

Studio Hoinkis

Photographer Unknown

UNKNOWN ~ 1930s

In November 1938, the above photo—strikingly similar to Karen Kuehn's 1997 one on the facing page—appeared in NATIONAL GEOGRAPHIC as an illustration for a feature entitled "The Panther of the Hearth." It was 60 years earlier, sources indicate, that the very first Siamese cat made its debut in the United States, sent to the White House as a gift to First Lady Mrs. Rutherford B. Hayes by the American consul in Bangkok.

Karen Kuehn

CALIFORNIA ~ 1996

"We were in California, out in a yard with several mattresses. I had in mind to illustrate at least one of a cat's nine lives. We did quite a few drops, but the cat never seemed to mind." Siamese cats, in fact, are often touted as the most avid aerial artists of the species. And though Karen Kuehn now has two cats of her own, she was temporarily cat-less when on assignment for the 1997 NATIONAL GEOGRAPHIC story, "Cats: Nature's Masterwork." Working with them, she laughs, was definitely seductive enough to "to turn me into a cat owner again."

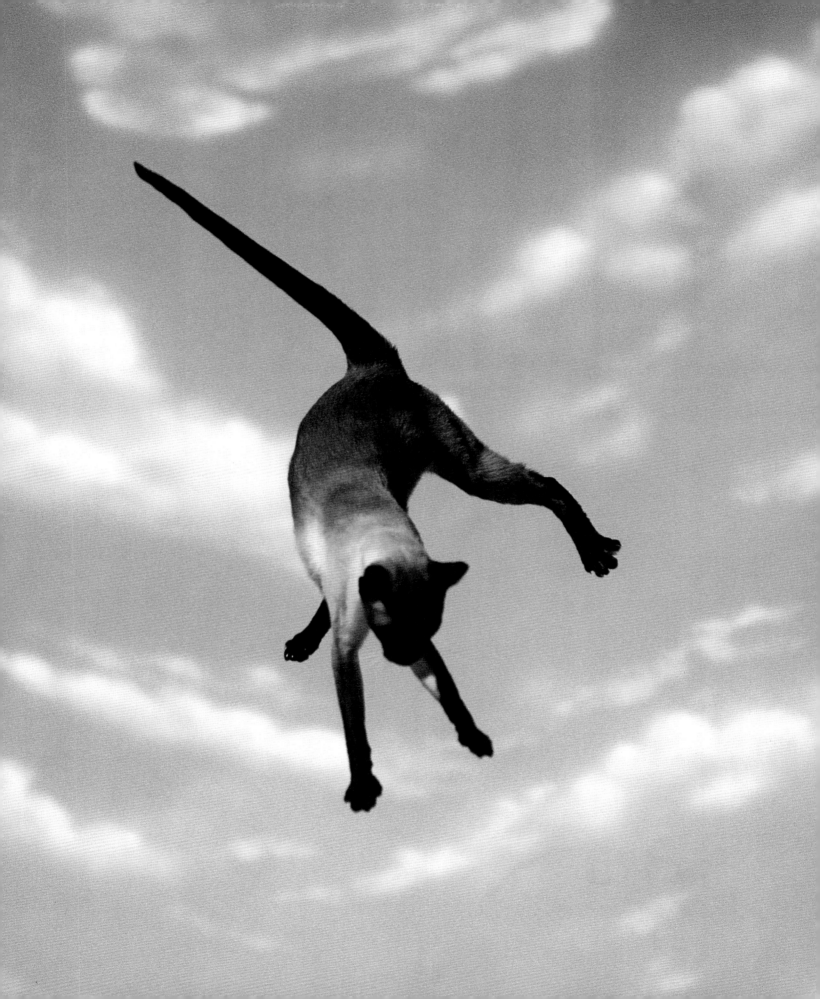

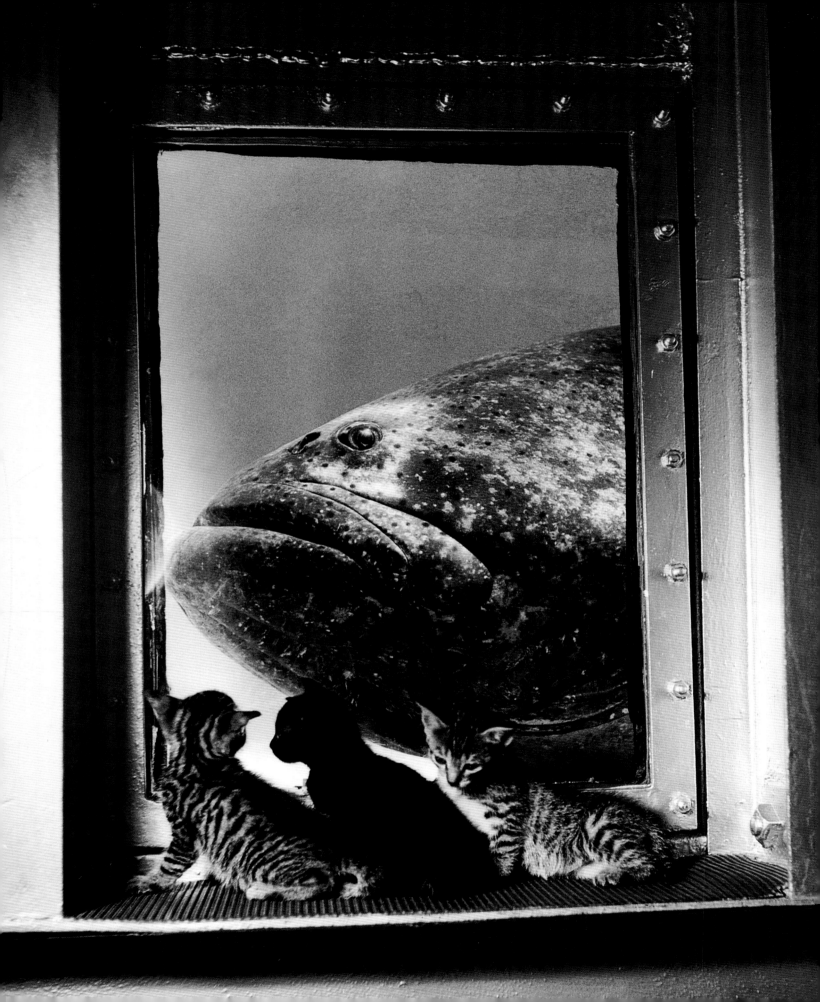

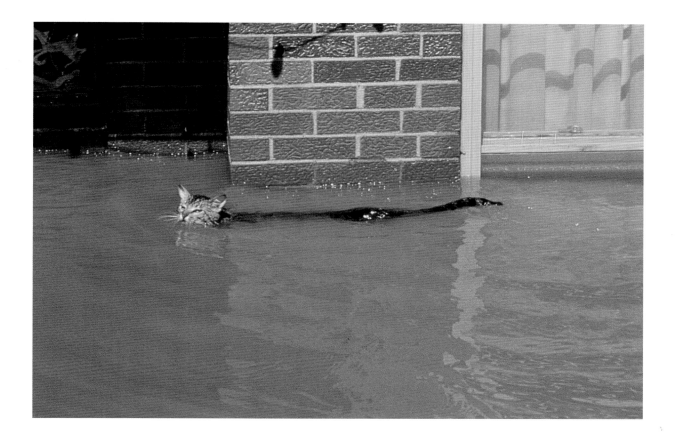

Luis Marden
FLORIDA ~ 1952

Marineland near St. Augustine,
Florida, was the world's first "ocea-
narium," opened in 1938. These
resident kittens, whose descendants
today still roam the park, were pho-
tographed by Luis Marden in 1952.
Looking at them now, one imagines
they were a bit uncertain what to
make of such a live-action "home-
shopping channel" for cats.

Rick Rickman
MISSOURI ~ 1993

The Mississippi River had flooded
and Rick Rickman was on the scene,
aboard a Coast Guard boat on a mis-
sion to rescue domestic pets. "We
were going through farmland where
the Missouri was running into the
Mississippi northwest of St. Louis,
and we stayed out there for the better
part of a day." Before this particular
animal finally cat-paddled its way to
a wide dry perch on a rooftop, it had
been pried loose from a tree branch
by one of Rickman's companions.
"But it got spooked suddenly and
jumped out of his arms back into the
water," Rickman explains. "We did
manage to take on board two dogs
and another cat, though."

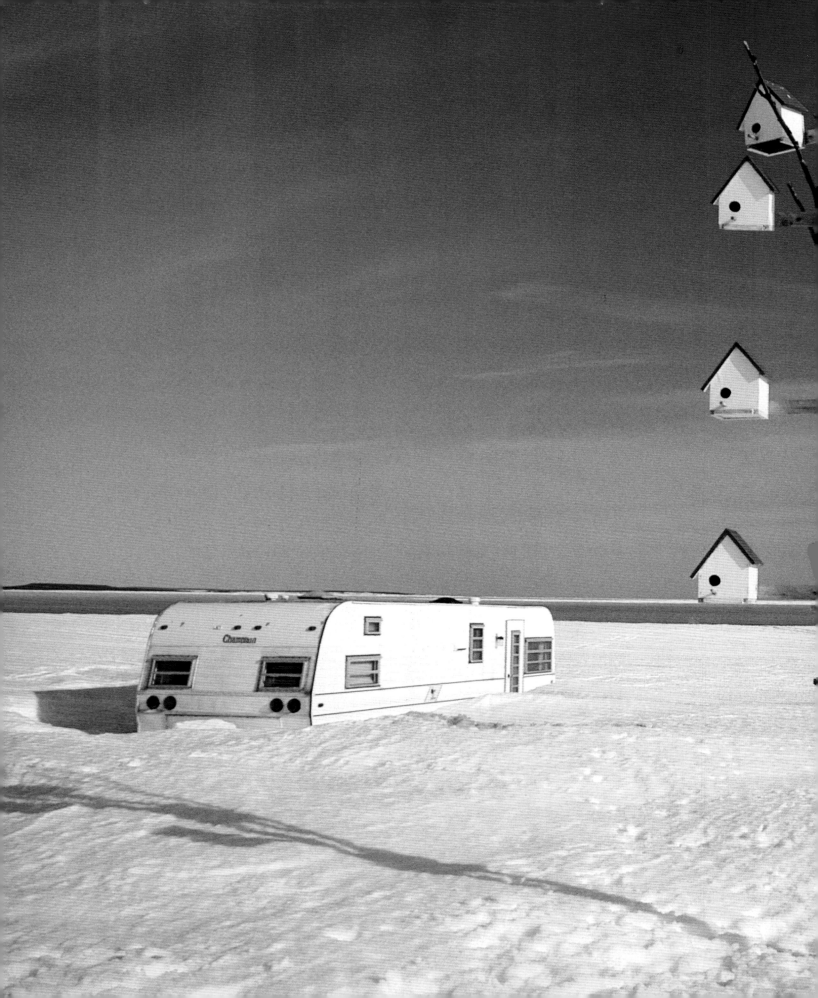

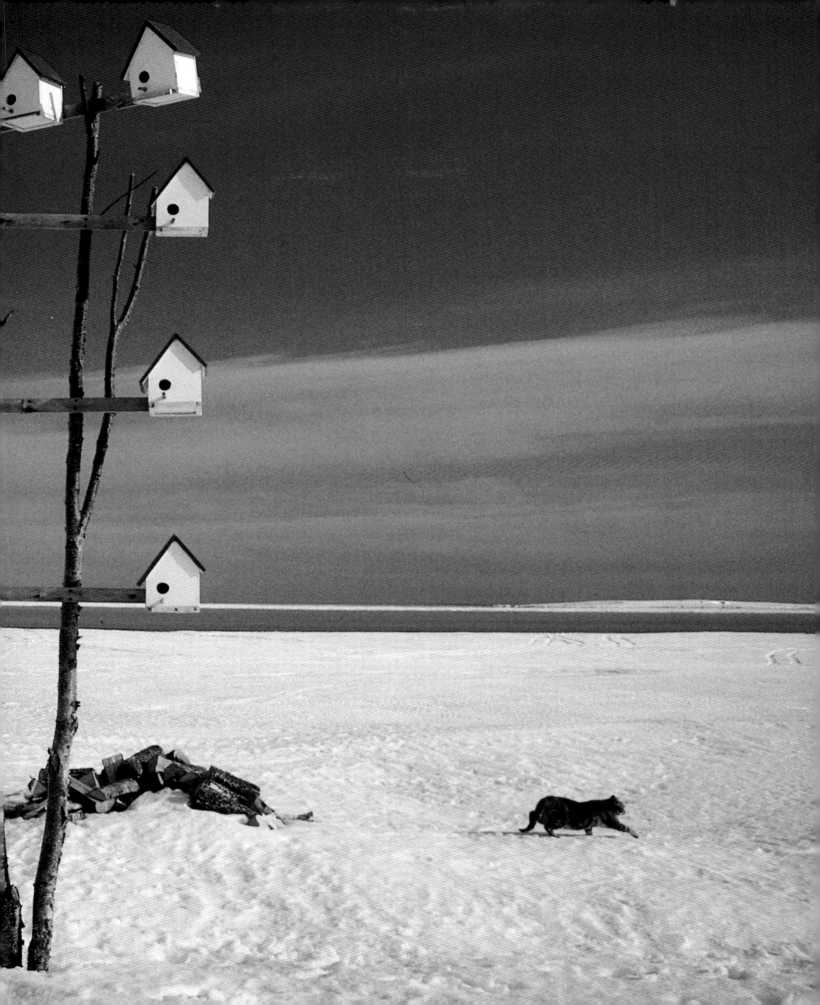

Tomasz Tomaszewski
CANADA ~ 1993

[*Preceding pages*] This image raises more questions than it can possibly answer. Where, for example, was this cat headed as it strides purposefully across a lonely snowscape? According to Warsaw-based Tomasz Tomaszewski, the trailer was empty, awaiting seasonal tenants after the spring thaw. The month is cruelest April, the place near Mingan, Quebec, along the western bank of the St. Lawrence River.

James L. Stanfield
GREECE ~ 1982

The first monastery was founded on Mount Athos, located at the tip of a peninsula in northeastern Greece, late in the tenth century. Today, approximately 20 monasteries of the Eastern Orthodox Church are established there, with many of the monks who belong to them dwelling as hermits. Father Spiridon feeds his cats. After taking his picture, Jim Stanfield couldn't help wondering: "Since females of any kind, human or animal, are forbidden on Mount Athos, where did the kittens come from?"

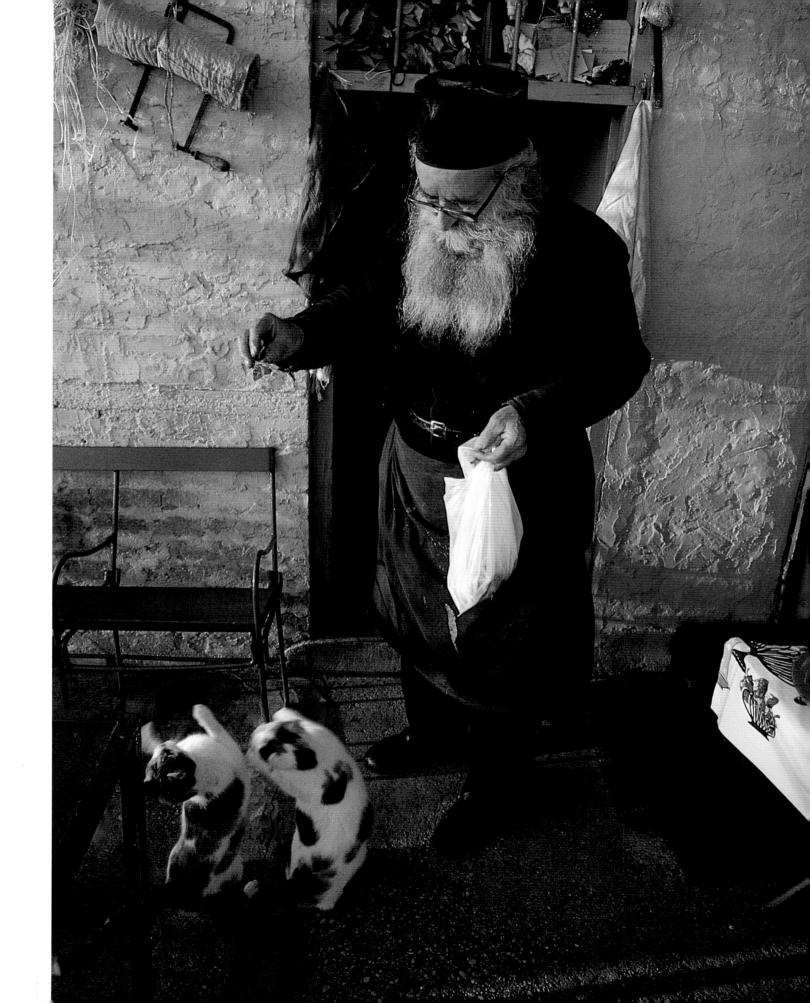

Kevin Fleming
GREECE ~ 1982

Greek cats, photographed by Kevin Fleming on the island of Sámos, are determined to have seafood for supper. What they will receive from the returning fishermen is that portion of the day's catch damaged in the nets. Men who ply the sea for their livelihood, in fact, are sometimes superstitious about cats, treating them with mistrust. An Italian proverb, however, should set them straight: "The cat loves fish, but hates wet feet."

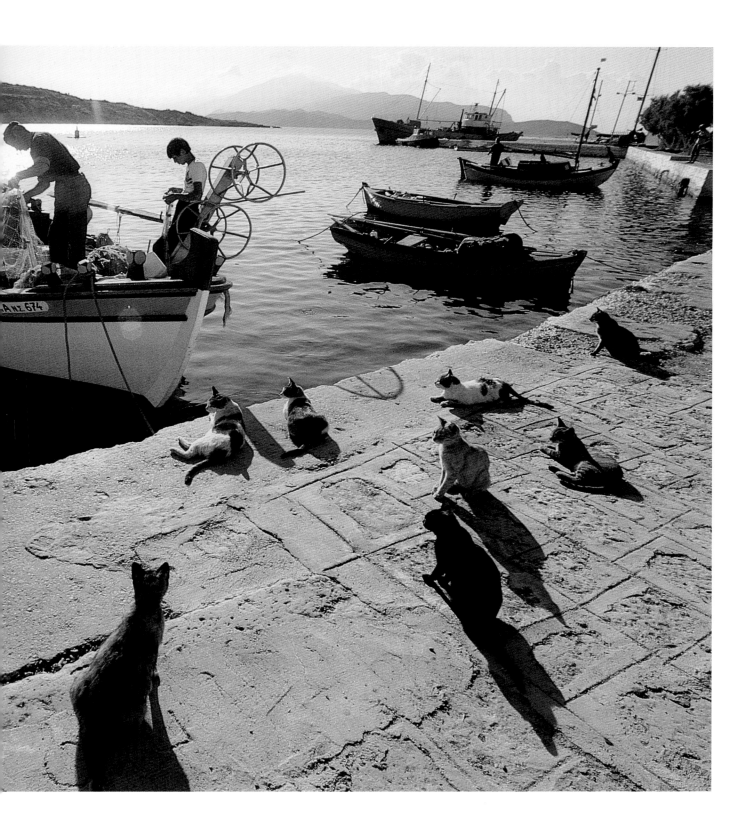

Karen Kuehn
CALIFORNIA ~ 1996

"It's always fascinating to watch a cat when it's stalking," says Karen Kuehn. "Wanting to get the point of view from the other end of the food chain, I set up a shot from the mouse's perspective." This cat, though, seems to be wearing a benevolent, somewhat amused expression. But why shouldn't it? A photographer, after all, bears little resemblance to lunch.

Nick Kelsh
ARKANSAS ~ 1977

Nick Kelsh visited Wildflower, the house of Billy Jo Tatum in Melborne, Arkansas, while photographing material for the book, *Nature's Healing Arts*. Tatum, author of an Ozarks recipe collection and a popular field guide to wild foods, has fond memories of the cat. "My kids named it Strabismus because it had crossed eyes. It used to love a fur pillow we kept on the couch. You couldn't tell where the cat stopped and the pillow began."

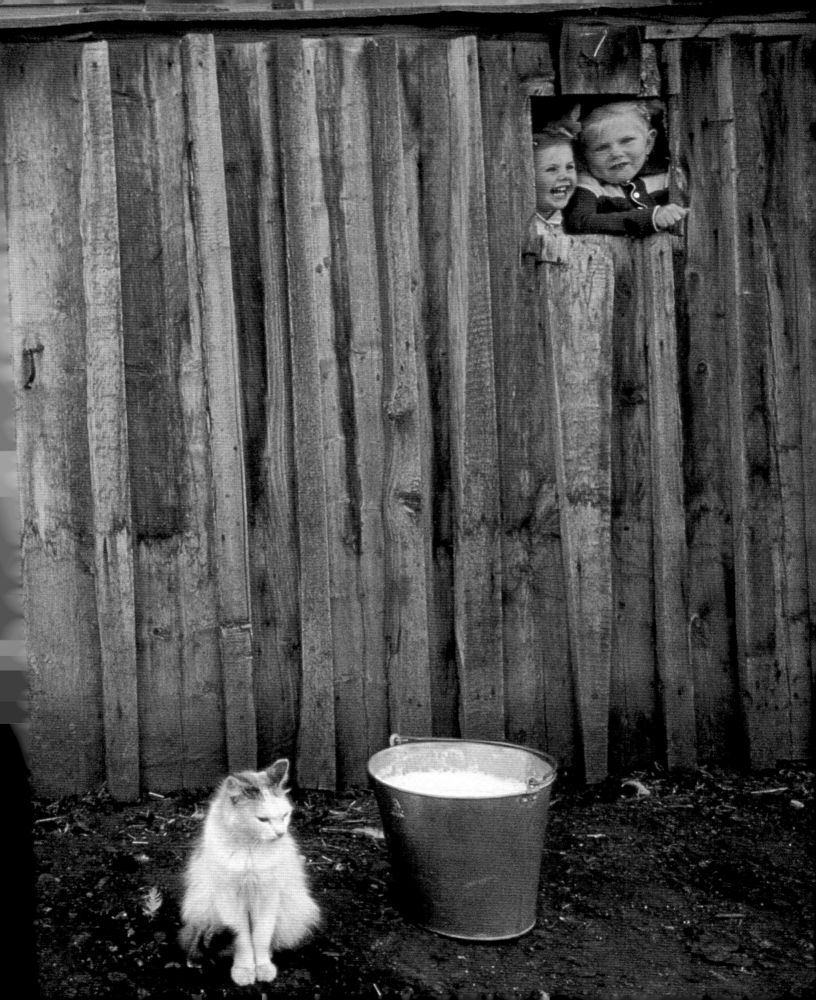

Gerd Ludwig
KAZAKHSTAN ~ 1991

[*Preceding pages*] In Kazakhstan, Gerd Ludwig learned, the privatization of the post-Soviet era dictated strictly, "one cow per family." Cats, however, were not being regulated. This well-behaved creature, he was told, had the household schedule down pat. "Whenever they milked, it would come around, but would wait patiently for its own bowl."

Donald McLeish
ITALY ~ 1935

Countless generations of homeless cats have had the run of the Forum in Rome. Here, in a 1935 picture by Donald McLeish, a photographer whose European studies were several times featured in the NATIONAL GEOGRAPHICS of the period, it's feeding time. To the early Romans the cat stood as a symbol for liberty, even before it was valued domestically as a mouser, and since there is no word in Latin for "purr," scholars suspect that the Romans did not at first make pets of these independent-minded creatures.

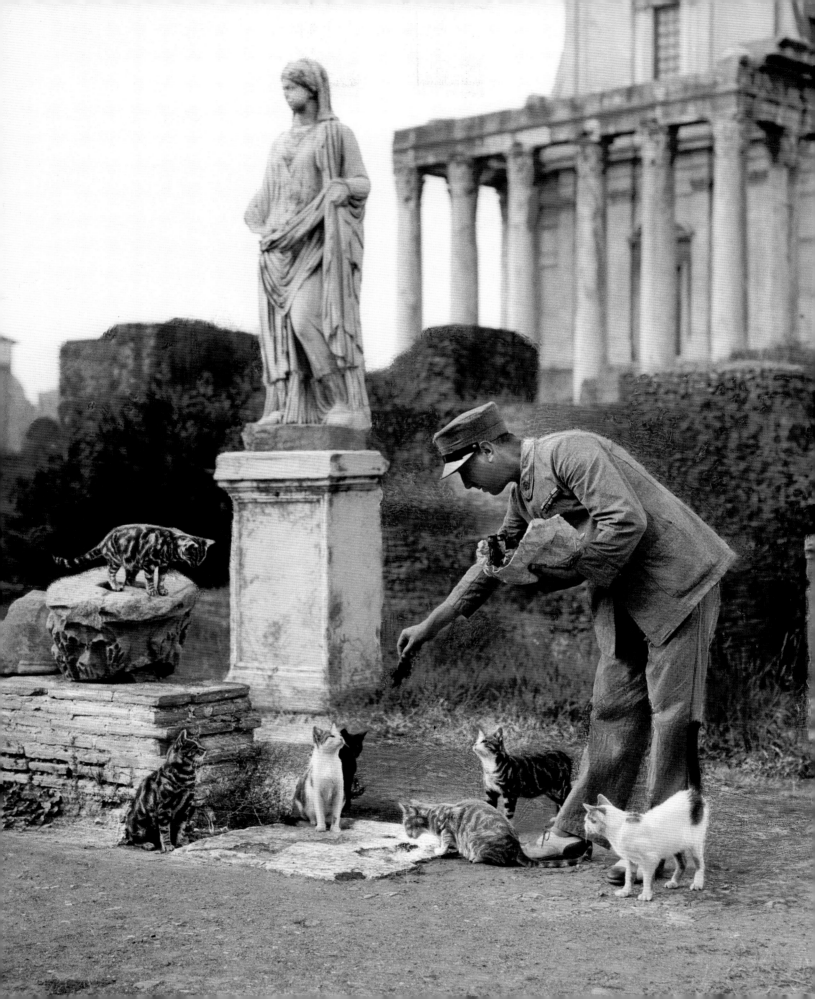

James L. Stanfield
FRANCE ~ 1988

In the Café Louis IX, on the Île de la Cité, a regular patron takes her *demi-pression* in the company of a cat named Caramel. Jim Stanfield saw this sedate pair while on assignment in Paris, covering the bicentennial of the French Republic. "There are no ordinary cats," insisted Colette, that most quintessential of Parisian writers, whose passion for animals was legendary and whose own nature was often described as catlike.

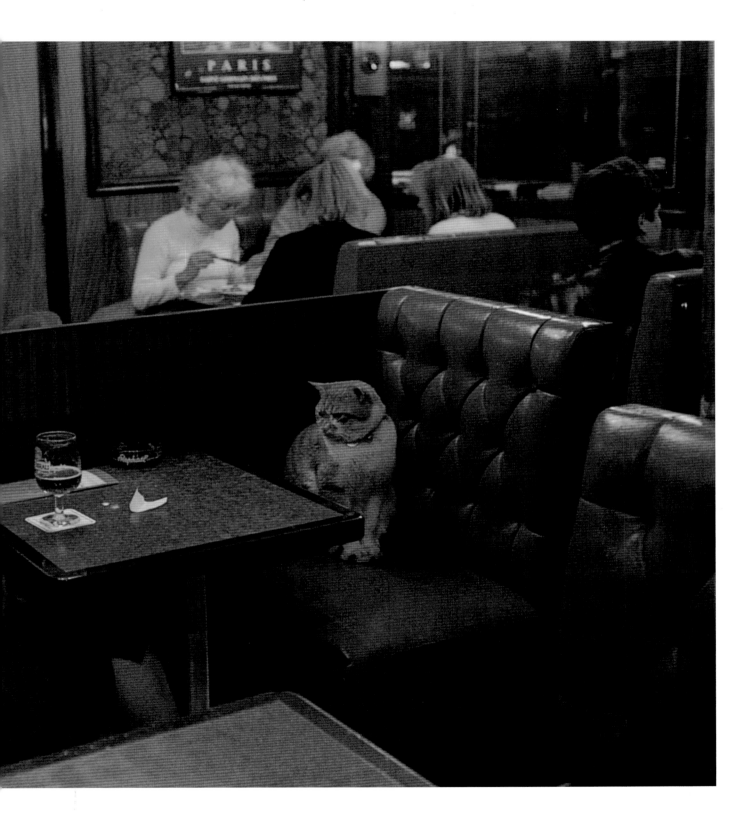

THE PHOTOGRAPHERS

Sam Abell

While growing up in Sylvania, Ohio, Sam Abell's father taught him his first lessons in photography. After graduating from the University of Kentucky in Lexington in 1969, Abell went to work as a freelancer for the National Geographic Society. He is currently on staff and has illustrated more than 20 articles and 6 books on various subjects. An exhibition based on excerpts from his book *Stay This Moment*, a retrospective monograph of his photographs, was shown at the International Center of Photography in New York City in 1990. Abell lectures and exhibits his photographs to audiences throughout the world.

Guillermo Aldana E.

Guillermo Aldana was born in Mexico on March 15, 1937. For many years, his photographs have appeared in NATIONAL GEOGRAPHIC magazine. He is particularly admired for his coverage of the Mexican earthquake in May 1986, and is possibly one of the only outsiders ever initiated by the Cora Indians of the Mexican highlands. Aldana's work has been published in 27 books—20 of them travel books to Mexico. He has promoted tourism in Mexico since 1951, as well as worked for the past ten years with a worldwide conservation project. When Aldana goes on assignment, he likes to take his dogs. His two cats prefer to stay at home.

William Albert Allard

William Albert Allard, the son of a Swedish immigrant, is one of the few professionals of his generation whose entire professional collection is in color. Allard has photographed more than 26 stories for the GEOGRAPHIC,

7 of which he also wrote. He has produced three books and is currently a staff photographer, Allard lives near Charlottesville, Virginia, with his wife, Ani, and their son, Anthony.

Bruno Barbey

The work of Bruno Barbey can be found both in books and international magazines such as NATIONAL GEOGRAPHIC, *Time, Life,* and *Geo.* His photographs have been displayed in solo exhibits in Paris, Rome, Zurich, Tokyo, Hamburg, and London. Barbey has covered periods of upheaval around the world—from Kurdistan and Vietnam to Palestine and Bangladesh. He lives in Paris but spends much time traveling in and photographing North Africa and Asia.

Sisse Brimberg

Sisse Brimberg was born in Copenhagen, Denmark, in 1948. She worked as an apprentice in commercial photography while attending school. After graduating, Brimberg established her own photography school in Copenhagen. Within five years, she received a Danish grant that allowed her to move to Washington, D.C. and study photographic techniques at the National Geographic Society. Now a freelance photographer for the organization, Sisse has covered more than 20 articles for the magazine. Her story on migrant workers received first prize for Picture Story of the Year from the National Press Photographers Association.

Ronald H. Cohn

The story of Koko's kitten earned Ronald Cohn public recognition and numerous awards including the Parents' Choice Foundation Award in 1989 for the video entitled "Koko's Kitten," and the New Jersey's Library Association Garden State Children's Book Award for "Koko's Story" in 1990. His background is in cell biology, and he currently is vice president and treasurer of the Gorilla Foundation in Woodside, California. He has worked as a photo editor for the *Journal of the Gorilla Foundation.* Cohn has been involved with several projects concerning gorilla behavior for the National Geographic Society.

Bruce Dale

A National Geographic Society staff photographer for 30 years until his retirement in 1994, Bruce Dale has worked in over 75 countries throughout the world. He considers his best images to be of serendipitous, unexpected moments. "I try to be sensitive to the world around me and actually plan on the unplanned picture. If I can capture the spontaneity and mood of the moment, then it becomes a more memorable photograph." In 1989, he was named White House News Photographers' Association Photographer of the Year and has twice been named Magazine Photographer of the Year by the National Press Photographers Association.

David Doubilet

David Doubilet, as a 12-year-old boy in New York City, took his first underwater pictures off the New Jersey shore with a Brownie Hawkeye. Sparking a lifelong love of underwater

photography, Doubilet has since dipped cameras into most of the world's major bodies of water during his more than 20 years as a freelance photographer. He has covered everything from shipwrecks to sharks to the blue waters of the South Pacific. He has written two books—and supplied photographs for a third book written by his wife, Anne, who is also a photographer. The couple lives in New York City with their daughter, Emily.

Melissa Farlow
Melissa Farlow, a freelance photographer, taught photojournalism and also worked as a staff photographer for the *Pittsburgh Press*, *Courier-Journal* and *Louisville Times*. She was also a member of a photographic team that won a Pulitzer Prize for coverage of desegregation of the public-school system. Farlow lives in Sewickley, Pittsburgh, with her husband, Randy Olson, also a freelance photographer, and their dog, Lucy. The couple teamed up for the 1994 GEOGRAPHIC article, "Our National Parks: Legacy at Risk."

Kevin Fleming
Kevin Fleming, a freelance photographer, has covered waterways and coastal communities for NATIONAL GEOGRAPHIC magazine. In 1982, he received several Picture of the Year and Magazine Photographer of the Year awards. He currently resides in Annapolis, Maryland.

David Alan Harvey
A native of San Francisco, California, David Alan Harvey has photographed more than 30 articles for the magazine including stories on Tokyo, Cambodia, the Berlin Wall, the Maya, and Spain. Harvey's extensive photographic coverage of Spain was exhibited at the Perpignan International Photo Festival in France. The photographer is a former National Press Photographers Association Magazine Photographer of the Year. Harvey lectures at various universities, museums, and seminars.

Chris Johns
This native of the Pacific Northwest lives on a small farm in Virginia's Blue Ridge Mountains with his wife, Elizabeth, daughters Noel and Elizabeth Louise, and son, Timothy. While working as a staff photographer at the *Topeka Capital-Journal*, he was named Photographer of the Year. He has also worked as a staff photographer and picture editor for the *Seattle Times*. He began working as a freelance photographer for NATIONAL GEOGRAPHIC in 1979, becoming a contract photographer later in his career.

Nick Kelsh
Nick Kelsh, a native of Fargo, North Dakota, was a photographic intern for the National Geographic Society in 1976. He has published several books, including *Naked Babies*, with Pulitzer prize winner Anna Quindlen, and *Sense of Wonder*—a reissue of Rachel Carson's classic. Kelsh loves to photograph children, saying "they are spontaneous, fun, and we've all been there." His next book, *Siblings*, is due out in 1999. Kelsh runs his own studio in Philadelphia, Pennsylvania.

Karen Kuehn
Karen Kuehn was a summer intern for the Society in 1985. The June 1997 issue of the magazine features her work in an article entitled "Nature's Masterwork: Cats." Kuehn lives in New York City in a family that includes two dogs, two turtles, and a Persian named Fraidy Cat.

Gerd Ludwig
Born in Germany in 1947, Gerd Ludwig attended the School of Photography at Folkwangschule, University of Essen, Germany. In 1974, Ludwig cofounded VISUM, Germany's prestigious photo agency, and photographed for it until moving to New York in 1984. He continues to photograph for European and American publications. Ludwig currently resides in Los Angeles, California.

Bill Luster
Bill Luster is the director of photography for the *Louisville Courier Journal*. He served as president of the National Press Association 1993-1994 and has won two Pulitzer Prizes. His portfolio includes many photographs of cats because "possibly they hold still longer than dogs." Luster likes to fly fish, and lives with his wife, Linda, and son, Joseph, in Kentucky.

Robert W. Madden
Bob Madden has contributed to several National Geographic Society divisions, including WORLD magazine, the Book Division, and NATIONAL GEOGRAPHIC magazine. He has been both photographer and picture editor for numerous articles, as well as the director of layout and design. Madden currently works in the Society's electronic publishing division.

Luis Marden
The *Washington Post* once described Luis Marden as "the epitome of a phenomenon once known as 'the Geographic man.'" Marden, who joined the Geographic in 1934, pioneered the use of 35mm cameras and Kodachrome film for the Society. He found and photographed the remains of Capt. Bligh's ship, the *Bounty*, and had uncountable adventures around the world. Chairman of the Board and former National Geographic Society President Gilbert M. Grosvenor once called Marden "so remarkable that he sometimes seemed a character out of fiction."

Donald McLeish
The late Donald McLeish was a staff photographer for NATIONAL GEOGRAPHIC from 1922 to 1935. He worked on varied assignments for the Society—ranging from the mountain ranges of the Scandinavian region to the royal family of England.

George F. Mobley
The virgin redwood forest that surrounded George Mobley's home in California instilled a sense of adventure in him as a boy. He fed his lifelong desire to see the world during a career of more than 35 years with the National Geographic Society. He has produced books on the White House during the Kennedy years, and has trekked the lands of Mongolia. His enchantment with the outdoors produced dazzling scenics for which he has received numerous awards. When not traveling, Mobley lives in the Shenandoah Valley of Virginia.

Albert Moldvay
The late Albert Moldvay was a contract photographer with the National Geographic Society from 1963-1976. From his first article on the Italian Riviera to his last article for the Society's magazine on Stockholm, Sweden, he imparted the distinct flavor of each region. On a trip to Madagascar, Moldvay teamed up with writer and explorer Luis Marden to bring the "island at the end of the Earth" back to the United States.

Richard Olsenius
Richard Olsenius, a Minnesota native, is drawn to landscapes that define people. He has covered stories on Alaska, Labrador, and the Arctic, but prefers the intricacies of the scenery closer to home. For the past three years he has worked as an illustrations editor for NATIONAL GEOGRAPHIC. His interest in music has inspired him to create a multimedia project that is due out in spring 1999. It combines the sounds of music and the images of photography with the technology of CD-ROMS. Olsenius currently lives in Annapolis, Maryland, with his wife, Christine.

Adm. Robert E. Peary
On April 23, 1909, 17 days after being credited as the first to reach the North Pole, Peary wrote, "I have won the last and greatest geographical prize, the North Pole, for the credit of the United States." Peary was associated with the National Geographic Society from its founding in 1888. The Society helped fund his exploration of the North Pole. The last photograph of the great explorer was taken on the steps of the Society's building.

Susie Post
Susie Post's first assignment for NATIONAL GEOGRAPHIC was the "Aran Islands: Ancient Hearts, Modern Minds," published in the April 1996 issue. She currently lives in Pittsburgh, Pennsylvania, and is working on her fourth story for NATIONAL GEOGRAPHIC.

Timothy W. Ransom, Ph.D.
Ransom works for the governor of the State of Washington, heading a team that assists local government and tribes in protecting Puget Sound's water quality and habitat. He has recently resumed his interest in photography and enjoys photographing the "human animal." Previously, he worked on various projects for the magazine concerning endangered species. Ransom currently makes his home in Olympia, Washington, with his wife, two daughters, a son, and a cat.

Charles Reid
The late Charles Reid was a photographer living in Wishaw, Scotland. In 1920, Franklin Fisher, director of illustrations for NATIONAL GEOGRAPHIC at the time, selected 492 of Reid's photographs that depicted various Scottish subjects or scenes. Fisher brought these images back to the Society for use in articles such as "Man's Oldest Ally, the Dog" in the February 1936 issue.

Rick Rickman
Pulitzer Prize winner Rick Rickman photographed the "California: Desert in Disguise" for the 1993 NATIONAL GEOGRAPHIC Special Edition on Water. He lives in Laguna Niguel, California.

Joel Sartore
Joel Sartore's photographic career began in 1984, when he worked as a photojournalist at the *Wichita Eagle*. He rose through the ranks to become the director of photography by 1990. In 1991, Joel took on his first freelance assignment for NATIONAL GEOGRAPHIC. Since then he has covered a variety of subjects from Hurricane Andrew to a National Geographic Society book on endangered species. Sartore lives in Nebraska with his wife and children.

James L. Stanfield
From rats to His Holiness, Jim Stanfield brings charm and elegance to any subject that he photographs. Influenced by a family of newspaper photographers, his first lessons in photography came from his father in Wisconsin. Since then, Stanfield's contributions to the field have been noted numerous times—the White House News Photographers Association has chosen him as photographer of the year four times. His photographs have been displayed on the walls of the Metropolitan Museum of Art in New York. A staff photographer for the National Geographic Society since 1967, Stanfield retired in 1996 but continues his association with the Society as a freelancer. When not traveling he can be found hiking near his home in Chincoteague, Virginia.

Maggie Steber
Since 1978, photojournalist Maggie Steber has documented the causes of human drama. Her work has taken her into the heart of upheaval—from Cuba and Haiti to the guerrilla war in Zimbabwe. Her first book, *Dancing on Fire,* is a culmination of her five years in Haiti. In 1973, she was named the first female editor for the Associated Press Photos in New York City. Her work has been honored with awards that include the Leica Medal of Excellence in 1987 and the Award of Excellence in the 1986 Picture of the Year competition.

Tomasz Tomaszewski

A 29-year veteran contributor to NATIONAL GEOGRAPHIC, photographer Tomasz Tomaszewski has traveled on assignment to the far corners of the world. He has a great fondness for animals, and when traveling through El Salvador in 1995, packed his rental car with pet food for the homeless dogs and cats. One time, after feeding a monkey, the pet's owners invited the photographer to join their circus. Tomaszewski lives in Warsaw, Poland, with his family and four adopted stray dogs.

Michael D. Wallace

Wallace voyaged through the uncharted waters of the Antarctica on the ill-fated ship, the *Terra Nova*. The ship sailed as the largest and strongest of the old Scottish whalers. Although the captain of the vessel, Capt. Robert Falcon Scott, perished during his return from the South Pole, the fate of this photographer is unknown.

Bernard Wolf

Bernard Wolf writes and photographs his own books—18 of which have been published. His work, focusing on people, their environment and social situations, has led him on visits throughout the world. His last book, *HIV Positive*, was a Booklist Editor's Choice for 1997. His newest book published in September 1998 is entitled *If I Forget Thee O Jerusalem*. Wolf's next project addresses life in Cuba today. The photo journalist lives in New York.

Michael S. Yamashita

Photographer Mike Yamashita spends an average of six months a year on the road, shooting for a variety of editorial and commercial clients. He's been a regular contributor to NATIONAL GEOGRAPHIC since 1979, covering such wide-ranging locations as Japan, the Sudan, and New Guinea—however, his specialty is Asia. Yamashita has his studio in Mendham, New Jersey, where he lives with his wife, Elizabeth, and their daughter, Maggie.

This book was inspired by Kathy Moran, lover of cats and photographs, and is dedicated to Jon Schneeberger, who understands the nature of both.

NATIONAL GEOGRAPHIC CAT SHOTS

Published by The National Geographic Society

John M. Fahey, Jr.	*President and Chief Executive Officer*
Gilbert M. Grosvenor	*Chairman of the Board*
Nina D. Hoffman	*Senior Vice President*

Prepared by The Book Division

William R. Gray	*Vice President and Director*
Charles Kogod	*Assistant Director*
Barbara A. Payne	*Editorial Director and Managing Editor*
David Griffin	*Design Director*

Staff for this book

Editor	Barbara Payne
Illustrations Editor	Kathy Moran
Art Director	David Griffin
Assistant Editor	Dale-Marie Herring
Writer	Michele Slung
Picture Researcher	Robert A. Henry
Illustrations Assistant	Janet Dustin
Production Director	R. Gary Colbert
Production Project Manager	Lewis R. Bassford
Staff Assistant	Peggy Candore

Manufacturing and Quality Control

George V. White	*Director*
Clifton M. Brown	*Manager*
Polly P. Tompkins	*Executive Assistant*

ISBN 978-1-4262-0581-1

This 2009 edition printed for Barnes and Noble by National Geographic.

10 9 8 7 6 5 4 3 2 1

Printed in China

Visit the Society's Web site at www.nationalgeographic.com.

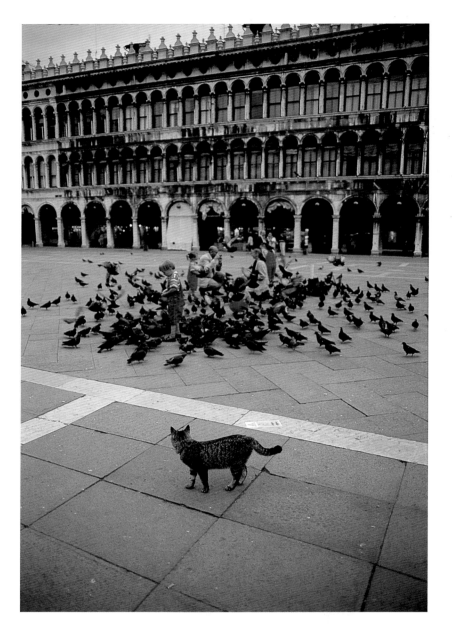

Sam Abell
ITALY ~ 1994

"Cats are inescapable in Venice," writes Jan Morris in *A Venetian Bestiary*.
"They slink from shadow to shadow before your tread, they leap like lightning
over garden walls, they scrabble among the market offal, they help themselves
adeptly to water from drinking-pipes, they are curled up fast asleep in the
shade of upturned gondolas, or on ancient palace steps." Always, Morris
tells us, they are on the lookout for benefactors. Here, one Venetian speci-
men has been caught by Sam Abell in the Piazza San Marco, unsure whether
to be more intrigued by the pigeons or the handouts.